LUNDY

A Landmark 50 Years

SIMON DELL

AMBERLEY

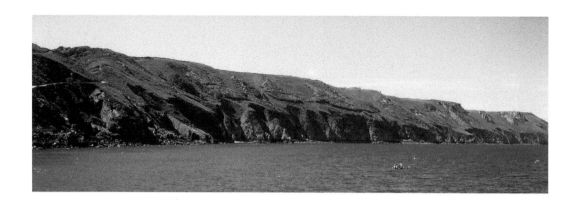

For my grandchildren, in the hope that they too might grow to love this magical place just as their grandfather did, as a schoolboy in the time of the Harmans when this story started.

First published 2019

Amberley Publishing
The Hill, Stroud
Gloucestershire, GL5 4EP

www.amberley-books.com

British Library Cataloguing in Publication Data.

A catalogue record for this book is available from the British Library.

ISBN 978 1 4456 5337 2 (print)
ISBN 978 1 4456 5338 9 (ebook)

Typesetting by Aura Technology and Software Services, India.
Printed in the UK.

Introduction

The celebration of fifty years for any organisation is a momentous achievement upon which to reflect. In 1969 Lundy came into the ownership of the National Trust as a result of the generosity of Jack Hayward, who provided the capital for its purchase. The Landmark Trust then stepped in and leased Lundy to manage, conserve and restore its buildings to their former glory and to look after its wonderful and unique landscape above and below the waves.

The austerity following the Second World War meant that Lundy was badly lacking resources and the whole island was in need of repair and restoration. A complete rethink was required and over the past fifty years the fortunes of Lundy have been turned around as a result of the close symbiotic working partnership that has grown over that time between the National Trust and the Landmark Trust.

The management of Lundy still lies in the control of both charities along with a number of other organisations dedicated to the long-term sustainability and enjoyment of this special place.

It is a credit to islanders past and present that Lundy is now open all-year round to visitors who wish to stay in the beautifully appointed accommodation on offer. A regular service provided by MS *Oldenburg* during the sailing season opens up Lundy to day trippers as well as delivering island supplies.

This book provides a glimpse at what it was like to visit Lundy in the 1960s and during that period of significant change and improvement under the aegis of the Landmark Trust.

It is a permanent visual record of what has been achieved over that significant half-century in the life of Lundy and the chance to also look forward to a bright future as we all work together to ensure its well-being for years to come.

Simon Dell MBE
Lundy

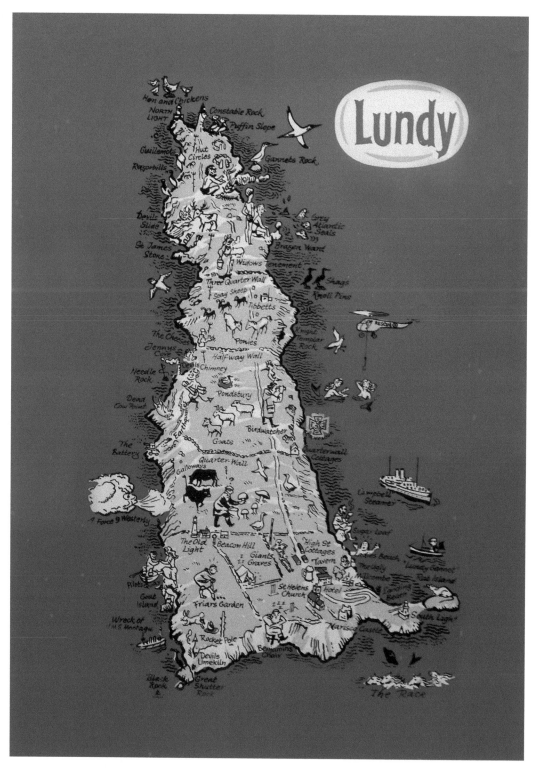

Lundy Before Landmark

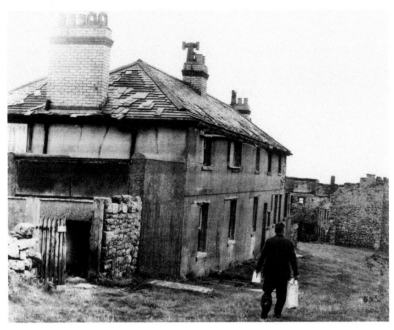

Lundy had been bought in 1924 by Mr Martin Coles Harman, pictured below with his son Albion and grandchildren at the memorial to John Pennington Harman VC, his eldest son, in VC Quarry. It was after the years of austerity that followed the Second World War that Lundy started to need much capital investment to ensure the upkeep of the buildings. As can be seen above, buildings started to become derelict and deteriorated very much. Martin Coles Harman died in 1954 and the island was left in the care of Albion and his two sisters, Ruth and Diana, along with Albion's wife Kathleen.

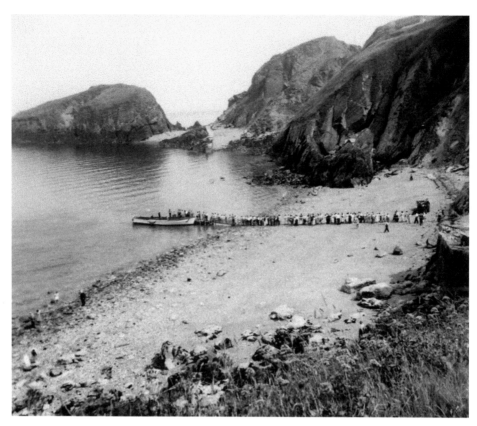

In the 1950s and 1960s day trippers came on the Campbell Paddle Steamers to visit Lundy and also to stay in the modest accommodation in the Manor Farm Hotel, which has now been subsumed by the main village buildings. Facilities were rudimentary and access not easy, with trippers being ferried to and fro on boats to the steamers. Many of the buildings were in a state of partial collapse, as can be seen in the main street 1960s image below.

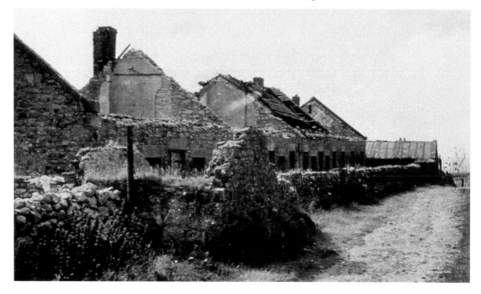

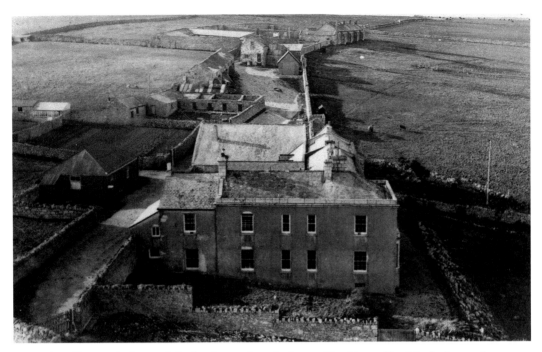

The village at the heart of the Lundy was in a tired state. The Manor Hotel in the image above, seen from the top of the church tower, was in need of considerable refurbishment. Tales of buckets in bedrooms catching rainwater coming through ceilings abound. Other cottages and properties such as Signal Cottages below, near the castle, did not fare much better. Signal Cottage, on the right, was occupied by tourists, but facilities were incredibly basic – one of the great attractions of the island!

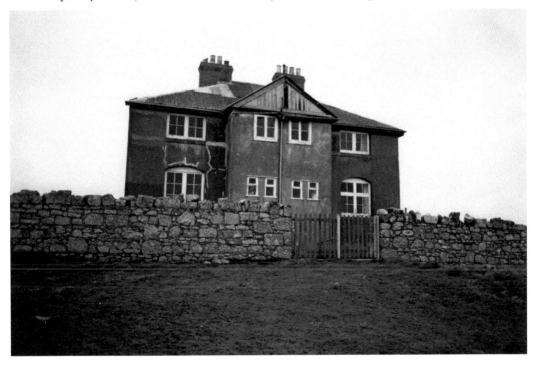

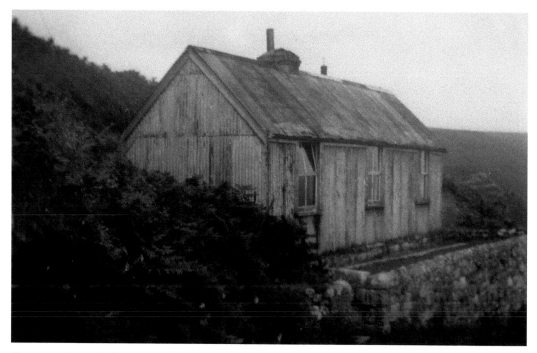

Hanmers, above, had originally been a 'fishing palace', constructed by the Sennen Cove fishermen, until it was later used as a holiday let. It was a wooden building whose roof leaked terribly. It was named after the Hanmer family who rented it as a holiday home for many years. The main house on the island was Milcombe House remaining the home of the Harman family and thereafter used for accommodation for visitors. The concave roof leaked and eventually a tar and wood flat roof was used to make it watertight. In the 1950s and 1960s it had a large porch, which no longer exists.

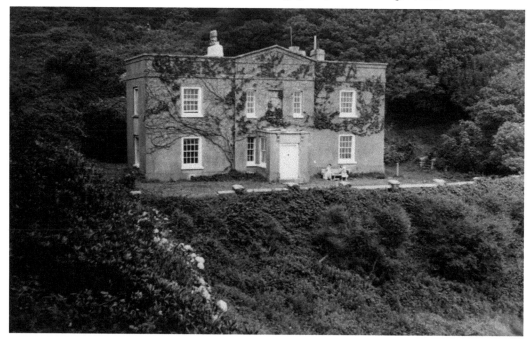

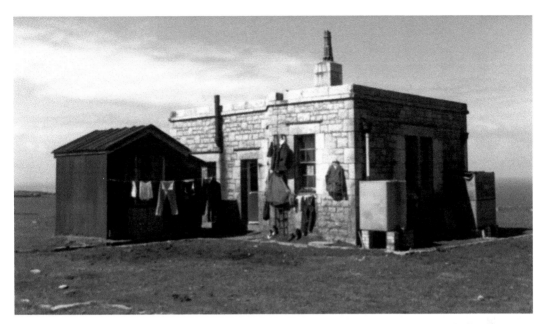

Further to the north on Lundy is the isolated building known as Tibbets. Originally built prior to the First World War as an Admiralty lookout and signal station, it is Lundy's most remote property. It has been used for many years as a holiday let, with the kitchen being in the wooden shed adjacent to the building. Although without mains electricity or water it made for a comfortable place to stay 2 miles north of the island village. Below, the castle keep was probably one of the more dilapidated buildings on the island, with the west wall having fallen down and the three internal cottages derelict by the 1960s.

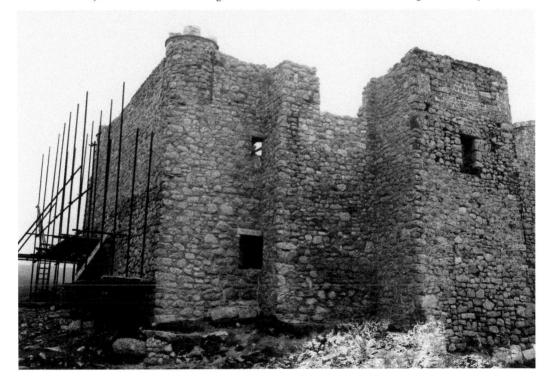

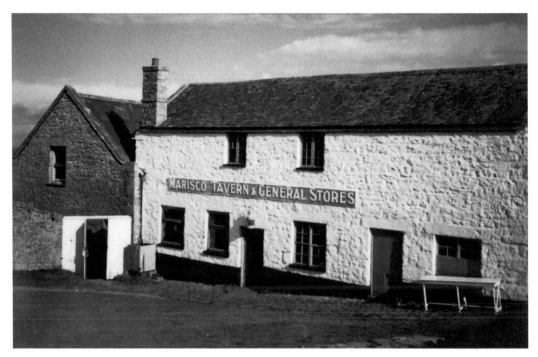

The Marisco Tavern & General Stores pictured in the 1950s was, and still is, the hub of the life of the village. Frequented, as the lower image shows, by the local South Lighthouse Keepers, it also housed the small island shop. Although the island stores has had a number of locations in the village, the Tavern was built for the quarry workers in the 1860s and remains today in the same location it always has enjoyed.

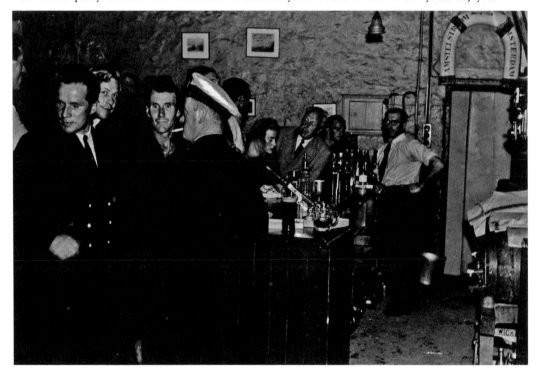

Pictured at the rear of the Tavern and Manor Farm Hotel is the quadrangle surrounded and enclosed by various wings of the hotel. It can certainly be seen in these early 1960s images that the hotel was in a poor state of repair and looked very run down indeed. The image above shows the corner of the quadrangle, which is now open to views between Old House South and Square Cottage, while the image below is of the corner now occupied by Old House North.

MANOR FARM
LUNDY

M _Dr. & Mrs Watson and family_ ROOM No. 3, 17, 20 & 24

19 71

		£	d
Brought forward, £			
Apartments and Attendance	_Board residence August 17th to 31st_	218	40
Breakfast			
Luncheon			
Tea & Coffee	_Early_	1	82
Dinner			
Supper			
Sandwiches			
Wines & Liqueurs		3	70
Spirits			
Ale & Stout			
Soft Drinks			
Cigars & Cigarettes			
Laundry			
Postage			
Puffinage			
	2 gallons petrol.		70
Radiograms		224	62
	Allowance for 52 packed luncheons.	9	36
		215	26
	2 bottles Piesporter.	2	80
		218	06
	Service	20	00
	Received with thanks	238	06
Carried forward, £	_F. Jade_		
	August 31st 1971		

A typical account from the Manor Farm Hotel on Lundy issued to Dr John Watson for his family's stay in 1971 at the very start of Landmark's tenure of Lundy. The bill for two weeks for four rooms amounts to £25 per week per room. The Watson family were frequent visitors during the time of the Harmans until 1968, and with Landmark after 1969. Dr Watson's daughters are still frequent visitors with fond memories of their late father's enthusiasm and love for Lundy.

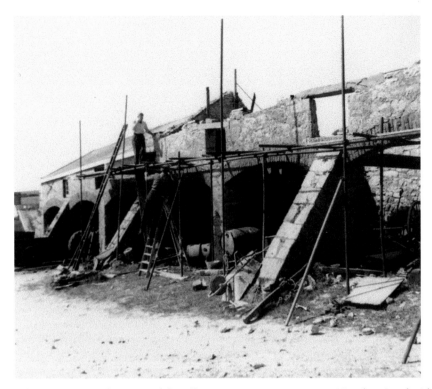

The Linhay buildings in the centre of the village were in a very poor state. Now housing the island fire station and shop, they were open to the easterly elements. The upper portion was used as a tea room on days when the paddle steamers visited and Mrs Davey recalls serving of a thousand cups of tea on busy days, just using a trestle table under the arch. The upper image shows the building that now houses the island shop, where on sailing days you might buy postcards and souvenirs.

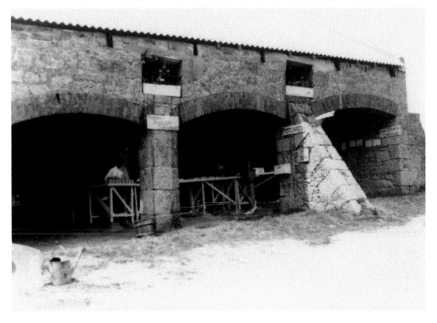

On the left is Albion Harman, overlord of Lundy until his premature death at the age of fifty-six in 1968. He is pictured here with his wife Kathleen, who lived to be almost 100 and was instrumental in making the decision with his sisters to sell the island in 1969. Below, in 1958, Albion Harman is shown bidding farewell to Her Majesty the Queen Mother on the first visit of a member of the royal family to Lundy. Behind Her Majesty is the distinctive figure of Felix Gade the island administrator and agent who served Mr Martin Coles Harman when the island was bought in the 1920s and continued until his death in the 1970s under Landmark ownership. He lived on Lundy for over fifty years.

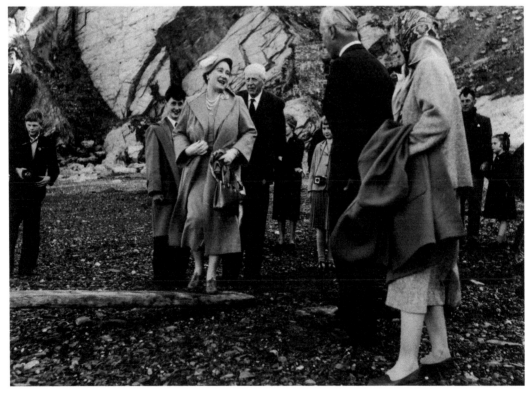

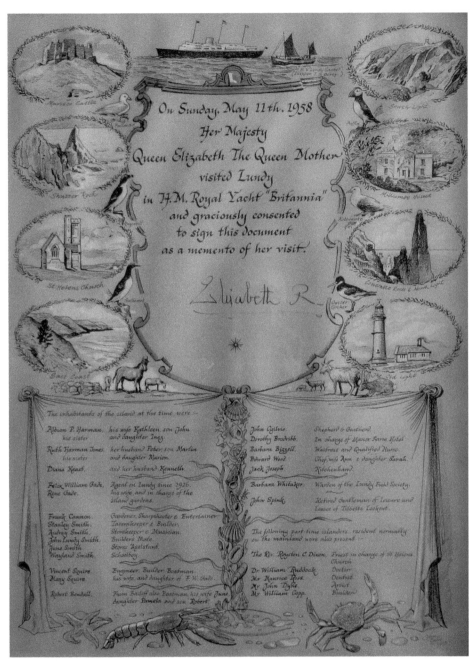

John Dyke, resident artist on Lundy, produced an illuminated certificate that the Queen Mother signed, along with the island staff present that day to commemorate her visit. Mr Dyke also produced the *Illustrated Lundy News* in the 1970s and 1980s. The certificate now hangs in Milcombe House. On 23 June 1968, Mr Albion Harman died and this left his sisters and widow with a difficult decision to take about the life and long-term viability of retaining ownership of Lundy.

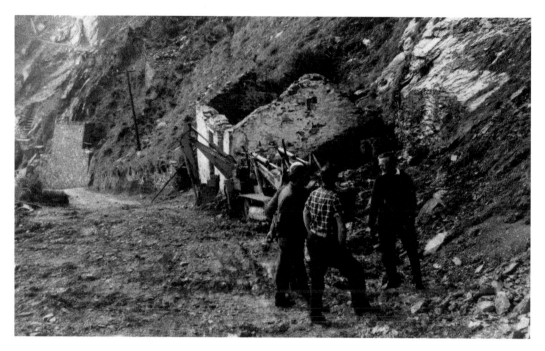

In April 1969 the main road leading up from the landing beach was subjected to a tremendous landslide that cut the island off from the beach and landing slipway. As can be read from an article in the *North Devon Journal Herald* of 1969, geologists and engineers were called in to assess the damage. As a result of the loss of the track from the beach, pedestrians could use the narrow and steep 'Goat Track' only. No stores could be taken up to the village. It was this single factor that resulted in the decision to offer the island to the National Trust to own and manage. The image above shows the damage to the roadway near Sea View Cottage.

16

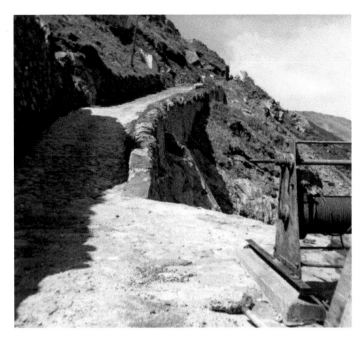

The image above shows the location of the game-changing landslide taken from the landing beach by the slipway winch, and shows above the site of the landslip above the white ruins of Seaview Cottage. The lower image shows Diana Keast (Mr Harman's sister) on the left talking to her brother-in-law Peter, who is with his wife Ruth over on the right. In the foreground is Mike Stafford on his accordion. It was Mike's son Ceri who worked on Lundy many years later.

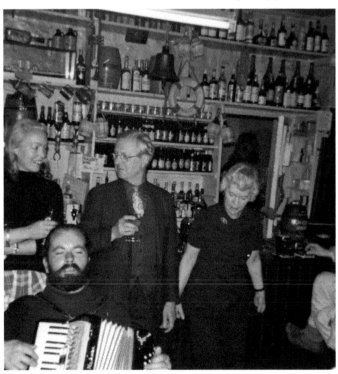

The Great Sale of 1969

LUNDY

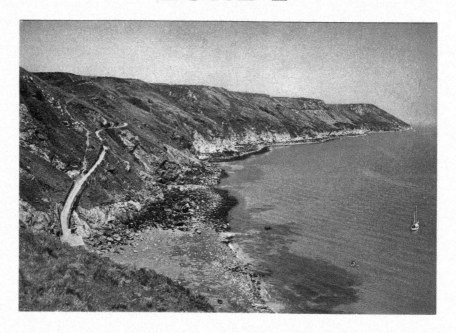

THIS ROMANTIC AND HISTORIC ISLAND

extending to

1047 ACRES

TO BE OFFERED FOR SALE BY PUBLIC AUCTION

at THE QUEEN'S HALL, BARNSTAPLE

on FRIDAY, 18th JULY, 1969 at 3 p.m.

(unless sold privately meanwhile)

AUCTIONEERS

PRICE, OGDEN & STUBBS,
79, Boutport Street,
Barnstaple (Tels. 4388/9),
North Devon.

SOLICITORS

ERNEST G. SCOTT & CO.,
31-32, Broad Street Avenue,
Blomfield Street,
London, E.C.2.
(Tel. No. 01–588 3171)

It was decided that the only practical means of securing the long-term viability of Lundy was to sell it. An offer was put to the National Trust in April 1969 to make an offer for the island. The National Trust was unable to buy it and a potential purchaser and donor was sought to see if the future of Lundy might be secured. An appeal fund was set up by the local North Devon Member of Parliament, Jeremy Thorpe, to raise funds to buy the island and donate it to the National Trust. Mr Thorpe was joined by Peter Mills, MP for West Devon, and also Dr David Owen, the MP for Plymouth Sutton.

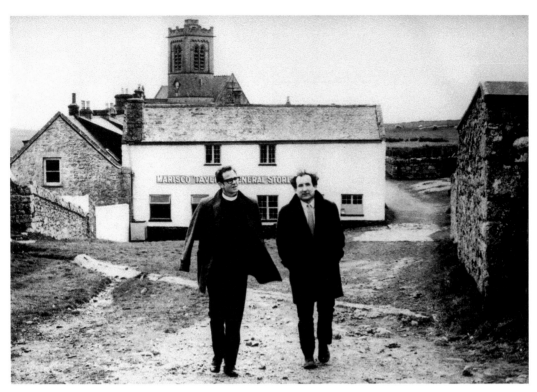

Various independent individuals and also a number of organisations made offers for the island. One offer was made by the Church of Scientology pictured above. Mr Peter Ginever, who was accompanied by Revd Alan Ferguson, said that they visualised Lundy as an ideal place on which to build a religious retreat. They made an offer on 15 April 1969. A group of Manchester casino owners also expressed interest in buying Lundy. It was decided that the island must go to auction. Below is another potential purchaser landing on the beach and being met by Diana Keast to show him around the area.

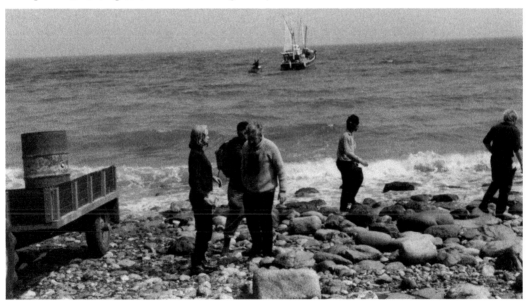

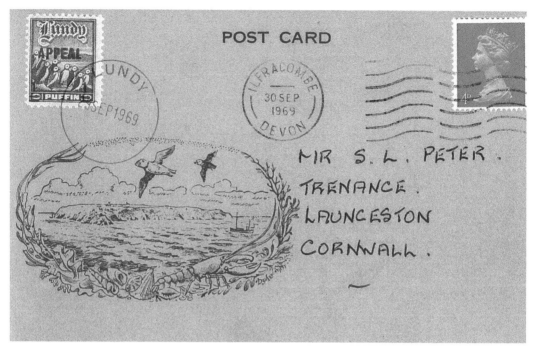

The appeal to buy Lundy was set up in 1969 and a special overprint appeal stamp was produced. Whenever donations made to the appeal fund to buy Lundy for the National Trust were received the recipient was sent a 'thank you' card printed with John Dyke's image of two puffins flying over Lundy, along with the appeal stamp. Lundy stamps are always placed on the left of a card with the UK stamp on the right. Below is an envelope dated 6 July 1969 with 'Good old Lundy' signed by Jack Hayward along with Peter Mills MP and Jeremy Thorpe MP. At the bottom is the distinctive signature of F. E. Gade, the resident island agent.

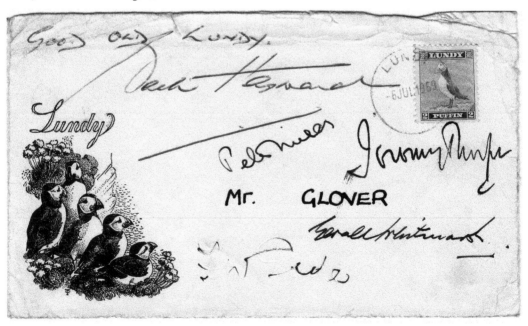

Landmark Arrives

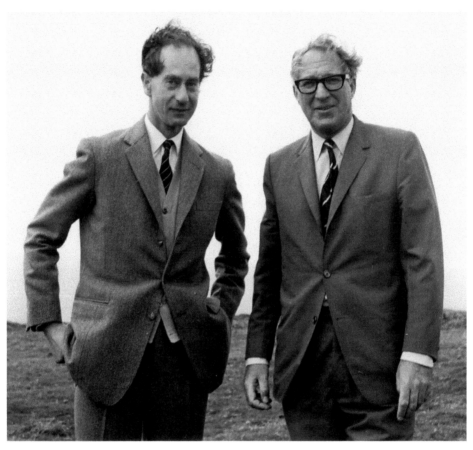

The auction of the island took place at the Queen's Hall, Barnstaple, at 3 p.m. on Friday 18 July 1969. Mr Jack Hayward, pictured above right, donated £150,000 to purchase Lundy and immediately donated it to the National Trust. The island was then leased to the Landmark Trust, the chairman of which was Mr (later Sir) John Smith for a period of sixty years. Below is John Dyke's caricature of the event, which he drew for the *Illustrated Lundy News* when he became the island resident artist.

A Great Day for the Island

Recognition of Jack Hayward's benevolence

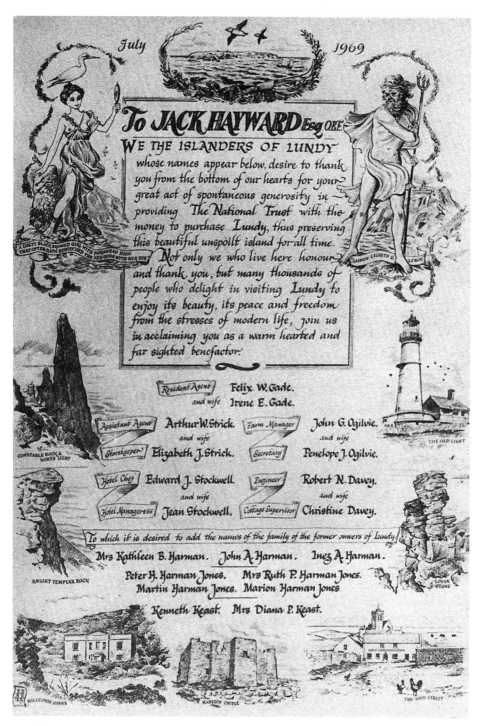

An illuminated certificate presented to Jack Hayward, signed by the residents of Lundy expressing the gratitude of the owners and those who lived on the island. His generous donation was added to with £100,000 from the public appeal that started the renewal and restoration of the island.

ILLUSTRATED LUNDY NEWS
AND LANDMARK JOURNAL

SUMMER ISSUE 1970 VOLUME 1 No. 1

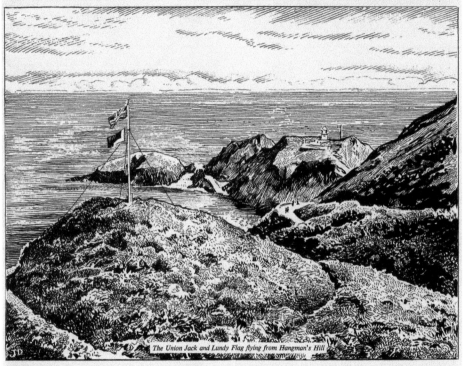

The Union Jack and Lundy Flag flying from Hangman's Hill

SUNDAY SEPTEMBER 28th

A LANDMARK IN LUNDY'S HISTORY

AFTER many anxious months, Lundy's future is assured, thanks to the action of Mr. Jack Hayward, The National Trust, the new tenants, The Landmark Trust, and the nation-wide appeal organised by the three Westcountry M.P's, Mr. Peter Mills, Mr. David Owen, and the Right Hon. Jeremy Thorpe.

The twin flags fly in celebration from the Masthead on Hangman's Hill, overlooking the Landing Bay, on September 28th, 1969.

The Island's blue and white flag was also unfurled at the same spot on another celebrated occasion when Her Majesty, the Queen Mother, spent a few quiet hours on the Island on May 11th, 1958.

The front cover of the new *Illustrated Lundy News* features the day of the handover of Lundy island on Sunday 28 September 1969 from the Harman family to the National Trust and the Landmark Trust. A landmark in Lundy's history was announced.

23

HYMN

ALL ye who seek for sure relief
In trouble and distress,
Whatever sorrow vex the mind,
Or guilt the soul oppress,

Jesus, Who gave Himself for you
Upon the Cross to die,
Opens to you His sacred Heart ;
O to that Heart draw nigh.

Ye hear how kindly He invites ;
Ye hear His words so blest ;
" All ye that labour come to Me,
And I will give you rest."

O Jesus. Joy of Saints on high,
Thou Hope of sinners here,
Attracted by those loving words
To Thee we lift our prayer.

Wash Thou our wounds in that
dear Blood
Which from Thy Heart doth
flow ;
A new and contrite heart on all
Who cry to Thee bestow.
Amen.

THE ADDRESS — by the Lord Bishop of Crediton

PRAYERS

For this island and those who administer it : for ourselves and our homes, and for all who sail the seas.

THE LORD'S PRAYER

HYMN

O GOD, our help in ages past,
Our hope for years to come,
Our shelter from the stormy blast,
And our eternal home ;

Beneath the shadow of Thy
Throne
Thy Saints have dwelt secure ;
Sufficient is Thine Arm alone,
And our defence is sure.

Before the hills in order stood,
Or earth received her frame,
From everlasting Thou art God,
To endless years the Same.

A thousand ages in Thy sight
Are like an evening gone ;
Short as the watch that ends the
night
Before the rising sun.

Time, like an ever-rolling stream,
Bears all its sons away ;
They fly forgotten, as a dream
Dies at the opening day.

O God, our help in ages past,
Our hope for years to come,
Be Thou our guard while troubles
last,
And our eternal home. Amen.

THE BLESSING

S. Helen's Church
LUNDY

A SERVICE

*to mark the transfer of the ownership
of the island of Lundy
to the National Trust*

28th SEPTEMBER, 1969
3.00 P.M.

On Sunday 28 September 1969 a service was held in St Helen's Church. Pictured here is the order of service used that day, featuring the artwork of John Dyke. The service was well attended, and the church full. Many visitors also gathered outside to hear the service being relayed for them by loudspeaker. Over 1,000 visitors arrived, with a capacity congregation at the service of 200 hearing an address by the Bishop of Crediton, the Right Revd Wilfred Westall, assisted by Revd R. C. Dixon, priest in charge of St Helen's Church.

THE NATIONAL ANTHEM

Minister : In this service we give praise to God the Creator of this wonderful world ; we thank Him for all the enjoyment in life and living ; we commend to His keeping ourselves, our future, and especially those who will have the care of this island.

We begin with the reading of a poem by S. Francis of Assisi — a man who loved everything in God's creation.
Reading — from " The Mirror of Perfection."

All join in saying :
We praise thee O God ; we acknowledge thee to be the Lord
All the earth doth worship thee ; the Father everlasting
To thee all angels cry aloud ; the heavens and all the powers therein
Holy, holy, holy, Lord God of hosts ;
Heaven and earth are full of thy glory.

HYMN

PRAISE the Lord ! ye heavens adore
Him,
Praise Him, Angels, in the height ;
Sun and moon, rejoice before Him,
Praise Him, all ye stars and light ;
Praise the Lord ! for He hath spoken,
Worlds His mighty voice obey'd ;
Laws, which never shall be broken,
For their guidance He hath made.

Praise the Lord ! for He is glorious;
Never shall His promise fail ;
God hath made his Saints victorious,
Sin and death shall not prevail.
Praise the God of our salvation ;
Hosts on high, His power proclaim :
Heaven and earth, and all creation,
Laud and magnify His Name !
Amen.

Reading — Psalm 111.

Minister : For the power to enjoy beauty and freedom, health and happiness
All : Heavenly Father we thank you

Minister : For all who through the ages have worshipped God and maintained the faith of Christ to this present day
All : Heavenly Father we thank you

Minister : For Hudson Grosett Heaven who built this Church, for the members of his family who beautified and enriched it, and all who have given generously of time and money to maintain or restore it
All : Heavenly Father we thank you

Minister : For all who have lived and laboured for the welfare of Lundy and her people, especially for Albion Pennington Harman who spared no sacrifice in endeavouring to maintain here an unspoilt island as a sanctuary for men, birds and animals
All : Heavenly Father we thank you

Minister : For the shelter afforded by this island to ships and sailors, and for the lightkeepers and others who have lived here to safeguard them in danger or distress
All : Heavenly Father we thank you

Minister : For the generosity of those who by their gifts great and small are making possible the purchase and preservation of this island
All : Heavenly Father we thank you

HYMN

NOW thank we all our God,
With heart, and hands and
voices,
Who wondrous things hath
done,
In Whom His world rejoices ;
Who from our mother's arms
Hath bless'd us on our way
With countless gifts of love,
And still is ours today.

O may this bounteous God,
Through all our life be near us,
With ever joyful hearts
And blessèd peace to cheer us ;
And keep us in His grace,
And guide us when
perplex'd,
And free us from all ills
In this world and the next.

All praise and thanks to God
The Father now be given,
The Son, and Him Who reigns
With Them in highest Heaven,
The One Eternal God,
Whom earth and Heav'n
adore,
For thus it was, is now,
And shall be evermore.
Amen.

Reading — from S. Matthew's Gospel, chapter 5,
vv 17-22; 27-29; 33-37.

Minister : Our past unfaithfulness in your service
All : O Lord forgive
Minister : Our neglect of opportunities to serve our fellow men
All : O Lord forgive
Minister : Our misuse of your gifts and of our talents
All : O Lord forgive
Minister : Our pride and selfishness, our lust and pleasure seeking
All : O Lord forgive
Minister : May the Almighty and merciful God forgive you your sins, strengthen you by his Spirit, and bring you to life everlasting ; through Jesus Christ our Lord. Amen.

24

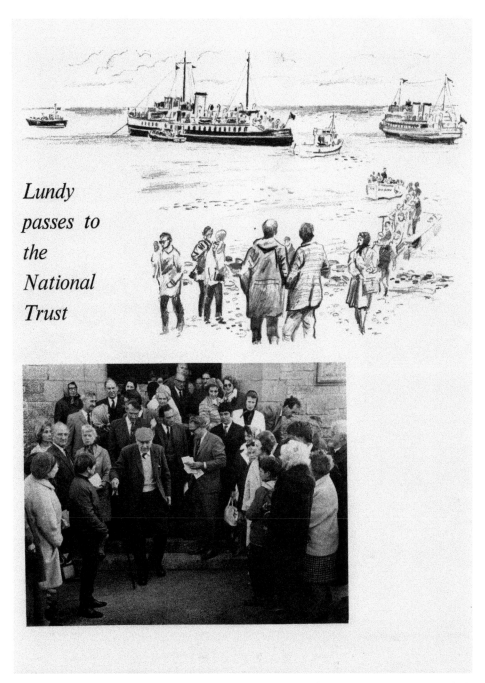

Lundy passes to the National Trust

A sketch by John Dyke showing the Friends of Lundy landing for the Thanksgiving Service held on 28 September 1969. The vessels *Westward Ho!* and *St. Trillo* were kindly loaned for the occasion by P&A Campbell Ltd to bring people across. Pictured is Mr Gade at the front, and on the left are Mrs Kay Harman and Mrs Ruth Harman Jones. Jack Hayward is in conversation with Jeremy Thorpe MP. Mrs Caroline Thorpe, in the headscarf and white jacket to the right, sadly died not long after this photograph was taken. To her right is Mr John Smith, chairman of the Landmark Trust until his death in 2007.

ALL THE YEAR ROUND

SAILINGS TO LUNDY

FROM

ILFRACOMBE QUAY

by M.V. LUNDY GANNET

Applications for passages, sailing dates and times should be made to Mr. A. G. Bealey, Cranford House, Woolsery, Nr. Bideford, North Devon. Telephone Clovelly 264

Nº 352 £8·50

Date 25- 5- 71 19......

LUNDY SAILING TICKET

per MV " Lundy Gannet "

Between Ilfracombe and Lundy

Issued Subject to the Conditions exhibited on the Island Vessels, etc

Fare Single or Day Return ~~35~~ - 2
 Children (3 – 14) ~~22~~/- 1·50

Throughout the later years of the Harman's ownership and well into the time of the Landmark Trust, the little trawler *H57 Lundy Gannet* serviced the island. Bringing stores and passengers, it was licensed to carry twelve passengers. She was built as a trawler in 1949 in Lossiemouth and had originally been called *The Pride of Bridlington* – hence her Hull registration number, which she retained when she left Bridlington in 1954 to come to Lundy.

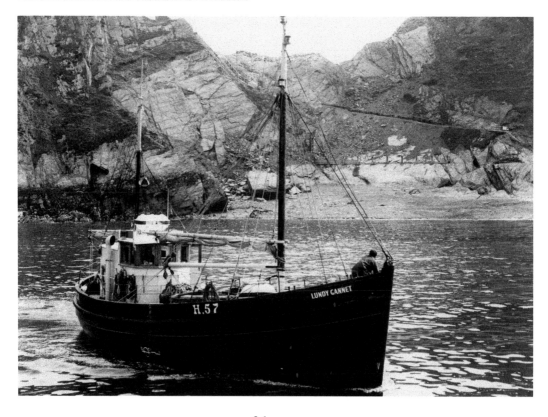

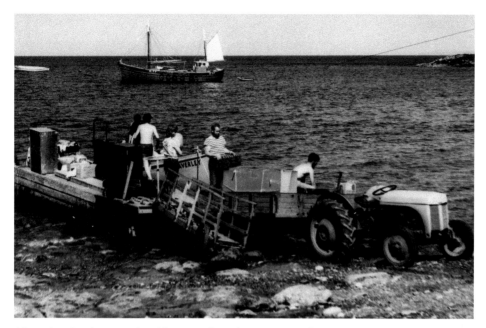

Above is a lovely example of how goods and stores, as well as passengers, were delivered to Lundy at the time of Landmark taking over. The *Lundy Gannet* unloaded into small boats, which were rowed ashore to the waiting mobile jetty brought down by tractor. Below is the first image of the staff of Landmark who started work in running the island. In the front is Mr Gade, who had been on the island for over fifty years and remained there for the rest of his life. Landmark retained him until his retirement and then he lived on a full-pay pension until his death in 1978.

The Landslide Repairs

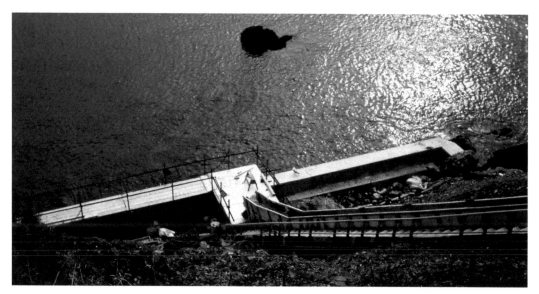

The first essential job that faced Landmark was the repairs and reconstruction of the landslip, which had been such a decisive factor in the decision to sell Lundy. The work was carried out prior to the church service to facilitate the arrival of 1,000 visitors for the event in 1969. In comparison with more modern-day repairs to the beach road, even this work seemed very basic in how it was completed with a single petrol-driven concrete mixer.

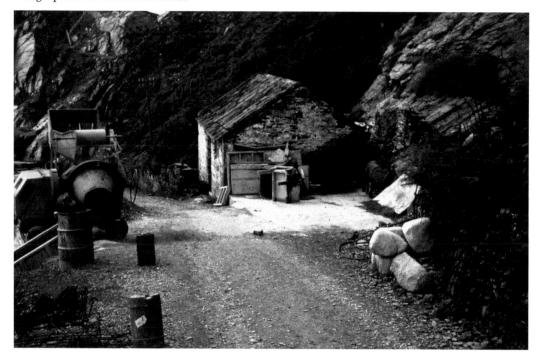

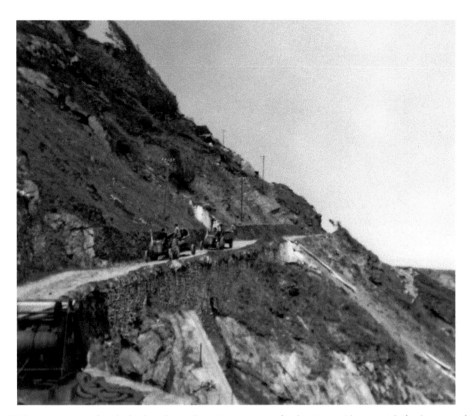

With repairs completed, the beach road again was open for business. Above, with fresh scars of the landslip still evident, the new concrete road winds its way steeply up to the village. Below, as seen from the deck of the *Lundy Gannet*, the area of the landslide to the right of the passing sailing boat is clear to see. This image makes it very obvious what a drastic effect the severed road had on the island, with transportation effectively cut off for stores and goods.

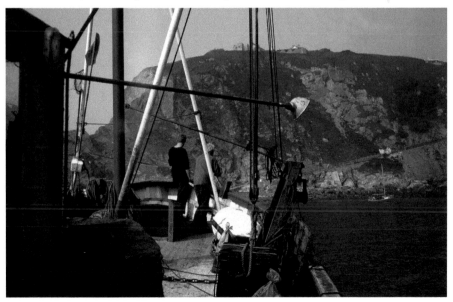

Work Commences – Brambles

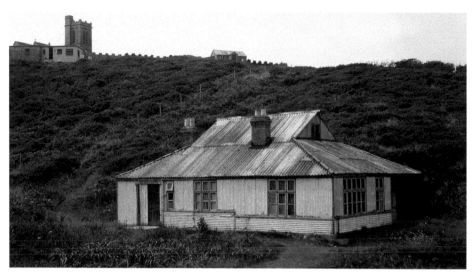

When Landmark arrived on Lundy, in the words of its founder John Smith, 'Most things on the island were wearing out, and, although it was exceedingly agreeable in that state, if the island was to remain inhabited and receive visitors, a great deal of expensive, unromantic and disruptive work had to be done.' One of the first things was to build a residence for the Landmark agent on the island, and it was decided to replace the old building known as Brambles. Here, above, is the original Brambles, which took little time with a tractor and chain to pull it down. The newly appointed agent who took over from Mr Gade was Mr Ian Grainger, and the architect from Landmark was Mr Phillip Jebb, who oversaw the work until the 1980s.

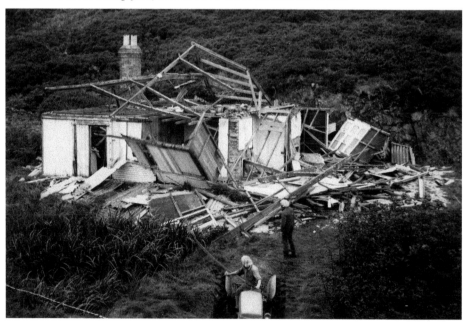

Brambles was replaced with a new wooden colonial-style dwelling, which is now still in use in 2019 as a holiday letting property. The building became the residence of the supervisor of the workforce, who were now needed for the complete reconstruction of the infrastructure of the island. Due to lack of resources since the war, most of the buildings were in need of repair. The Manor Farm Hotel had serious dry rot and a leaking roof, and Millcombe House had similar problems. The barn and the castle were ruinous and the Old Light was in poor shape. A great deal of work was planned, with a substantial workforce needed to carry it all out.

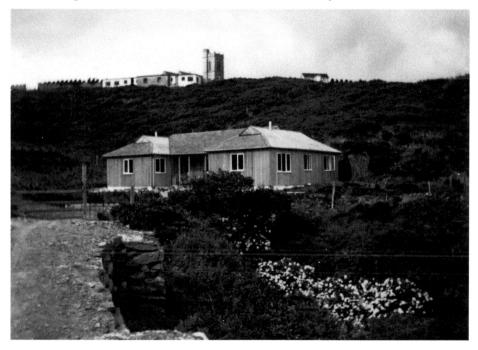

Construction of Quarters

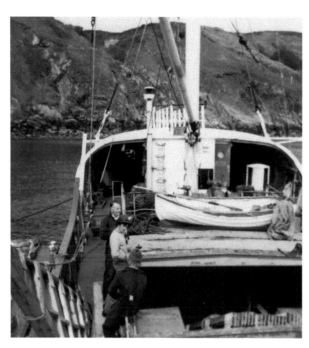

An effective means of transporting building materials to the island was needed. All materials have to be shipped, landed and handled many times, making their cost over double what it is on the mainland. An efficient means of doing this had to be found since the existing *Lundy Gannet* could not cope with the increased cargo. The transport question was resolved when Landmark bought a sturdy ship (which they called the *Polar Bear*) from the Danish government. The vessel was designed to work off Greenland and is pictured here carrying the prefabricated Quarters buildings. Bob Bendall was mate on the *Polar Bear* and is to be seen without his hat at the rear of the group. Below shows the construction of Quarters, the temporary prefabricated dwellings for the workforce rebuilding the island.

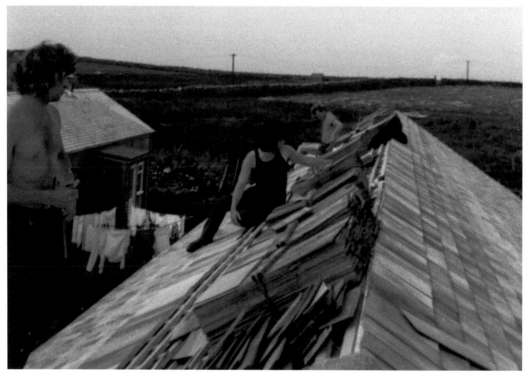

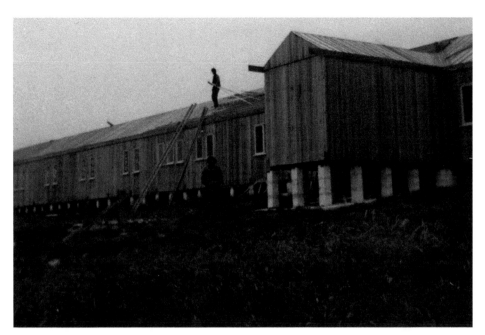

The first cargo to arrive on the *Polar Bear* was a ready-built replacement for Brambles, the old bungalow in St John's Valley. Next came Quarters, as shown here under construction, prefabricated buildings running at right angles from the High Street behind the shop. Erecting these buildings and making them safe against the extreme winds was a major enterprise. To collect more water a large prefabricated tank was installed on the path to the Old Light. An existing, conspicuous and dirty water tank on the summit of Castle Hill was put underground. All essential work was carried out by a very flexible crew and staff on the island who lived in these wooden dwellings. The dwellings were so well built that in 2019 they are still lived in by island staff and are clearly shown in this lower image of the village, which better resembles a building site.

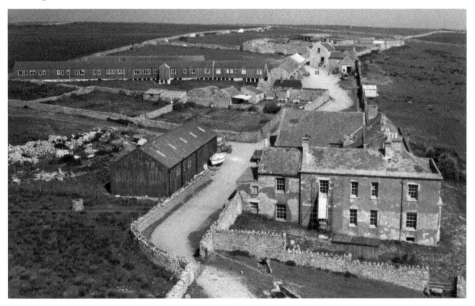

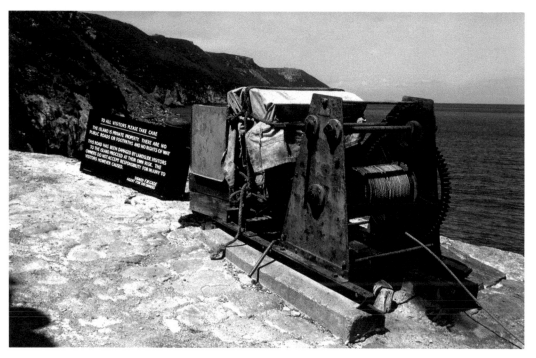

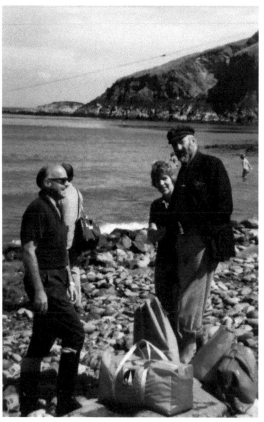

To cover the final stretch of sea from the *Polar Bear* to the landing slipway a special landing craft, the *Shearn*, was built in Ilfracombe by Mr John Shearn, *Polar Bear*'s engineer. Strong enough to withstand Lundy's rocky shore, it had wheels to allow it to be safely beached when not in use. It was winched up the beach using a strong-powered winch on the slipway as shown above. On the left is the tall bearded figure of Revd Donald Peyton-Jones, priest in charge of Lundy and simply known as 'PJ'. He replaced Revd Dixon as vicar at Appledore in the early 1970s. He is seen talking with Agent Bob Gillett and wife in 1978.

The Village

The village was sorely in need of a complete restoration. Pictured on the right is Mary Gade, daughter of Felix and Irene Gade. Mary grew up on Lundy, having made her first crossing from Bideford at the tender age of just eighteen days. She has spent much of her adult life living and working on the island. With the buildings in place for the workforce, renewal work could start in earnest. John Smith, with the help of his architect Philip Jebb, drew up a list of clear objectives that planned to restore and improve the internals of all the important buildings without marring their outside appearance. They also intended to install modern power supplies and drainage and ensure an adequate supply of potable water. The lower image was taken just prior to the construction of Quarters in the field to the upper left of the village buildings.

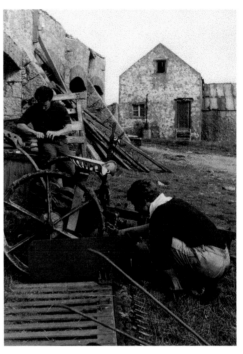

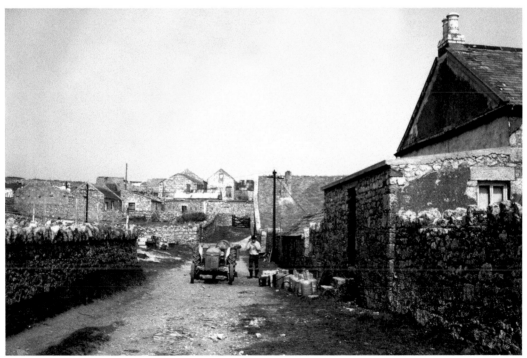

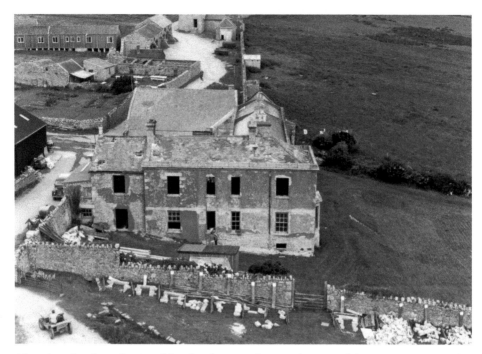

Above is a view from the top of the church tower, showing the state of the Manor Farm Hotel in 1969. In order to reconstruct the centre of the village much of that building has to be removed and rebuilt as shown in the lower image. John Smith's objectives were to improve the facilities for visitors, yet preserving Lundy's qualities as 'a world apart' and to repair and strengthen the Beach Road, but not making the island too easily accessible.

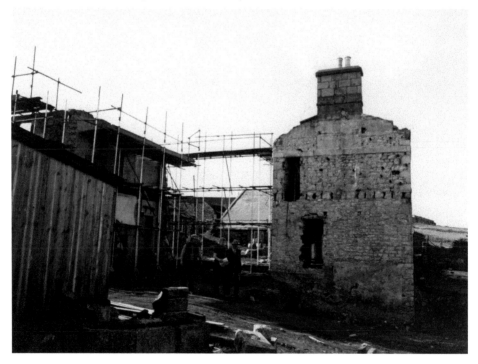

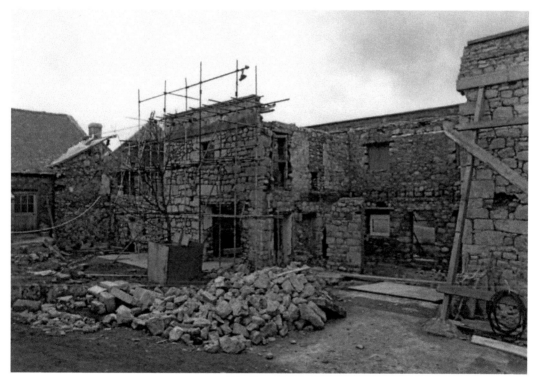

These two images show the rear of the former Manor Farm Hotel in the area now occupied by the modern-day Old House North and also Old House South cottages. Those who know the former hotel building can see how much of a rebuilding project was involved to replace the accommodation. The first aim was realised between 1971, when work started on Millcombe House, and 1983, when restoration of the old Manor Farm Hotel buildings culminated in the opening of an enlarged Marisco Tavern. In that time, some dozen buildings had been extensively restored.

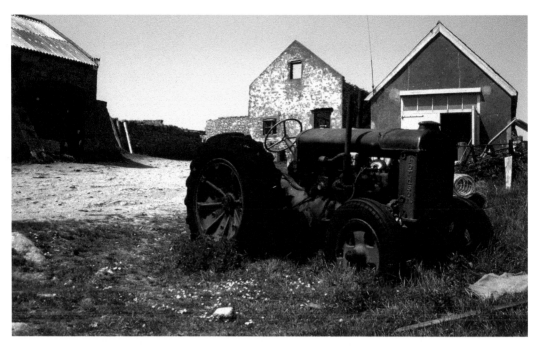

Above is the original Fordson tractor, which arrived during the Second World War for land improvement and agricultural purposes. Behind it is the great barn, in need of restoration, and to the left is the Linhay, which was soon to be restored. Past the tractor can be seen Signal Cottages, home to John Dyke the artist, adjacent to the ruins of the castle. Along the skyline to the right on the high ground is the open-air water tank reservoir, which collected water for the Signal Cottages and the Coastguard row of houses, already demolished prior to this photograph being taken. It was John Smith's intention to rebuild the castle again and make it a prominent feature overlooking the landing beach by removing the other buildings beside it.

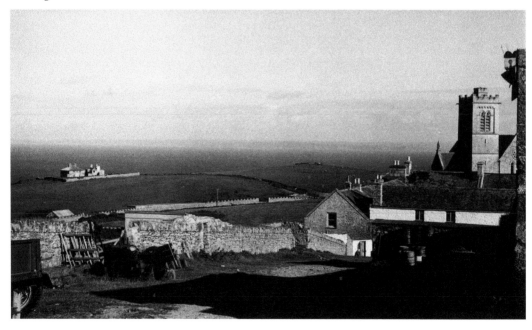

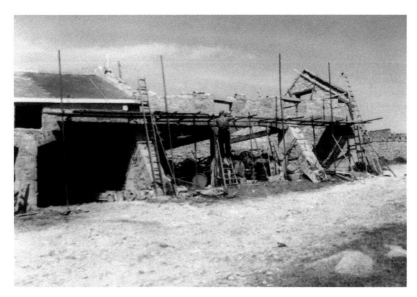

The rebuilding of the derelict Linhay provided accommodation in which the modern shop is located along with today's fire appliance garage. It is also the store where vital bottled drinking water is kept. The upper end of the Linhay then became a reading and exhibition room for several years. With the acquisition of MS *Oldenburg* in 1986, day visitors began to increase again and by then more people were staying on the island too. It grew increasingly obvious that on busy days the Tavern staff were hard-pressed to both serve drinks and meals and look after the shop in addition.

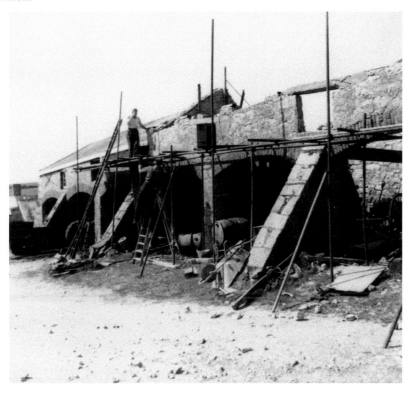

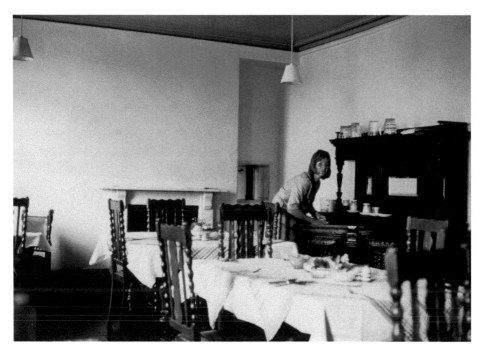

In the early days of Landmark the Manor Farm Hotel continued to run as a business. These images, taken in the hotel's last years, show how basic that accommodation was. But that was what people travelled to Lundy for, and the hotel is fondly remembered for the Landmark welcome that guests received amid dripping buckets and ongoing repairs. It was all part of the charm of Lundy. When Landmark took over Lundy, the hotel building, through lack of resources to carry out repairs, was truly in desperate straits. It was decided to abandon it for the time being and transfer the island hotel to Millcombe House.

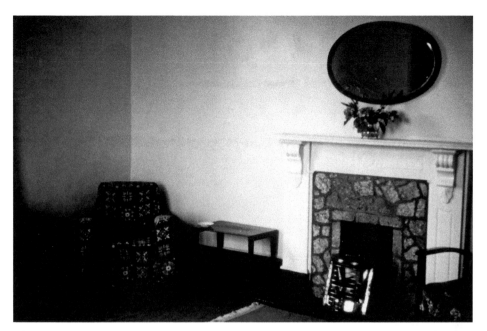

There were plans to convert the old hotel into a museum with accommodation, but financial considerations forced these plans to be abandoned. The agreed solution was to demolish the Big House and the Harman additions, thereby restoring the building to its former satisfactory Georgian appearance. During 1982 and 1983, Ernest Ireland Construction Ltd of Bath undertook the work under the supervision of the architect Philip Jebb. For this and the other works in progress at the same time, up to thirty men were employed on the island. They worked in four-week shifts then had a week on the mainland, travelling by helicopter to Hartland Point then via bus to Bath.

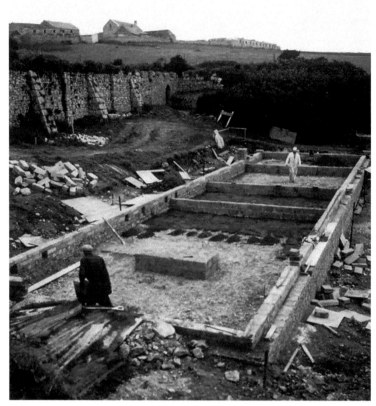

Government House is a completely new building and is mainly built of dressed granite reused from the demolished additions of the old Manor Farm Hotel. This was carried out in 1982. The front door lintel was taken from the Belle Vue Cottages at the quarry overlooking the east sidelands. The name Government House reflects the fact that it was intended to house the island agent, but John Puddy, who was appointed agent the year it was completed, preferred to stay where he was living already, as engineer. The property therefore was made available for visitors instead.

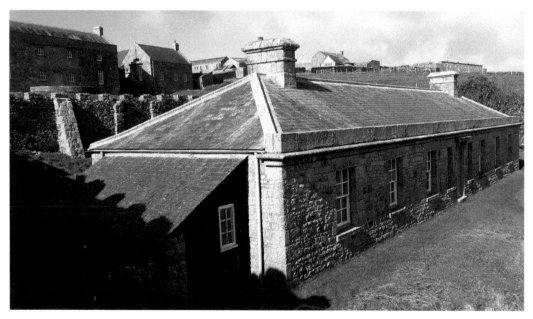

The small storeroom in the quadrangle was used by Mr Harman to house the small electric generator, which provided power and light for the Hotel and Millcombe House. This was replaced in the 1950s by a larger generator housed in a new building behind the tea garden. At around the same time it was decided to move the island's radio transmitter from the Old Light, where it had been since 1930. A good home for it was found in the now empty hotel generator room, which thus became the Radio Room. It seems extraordinary that until then, every day at 9 a.m. and 4 p.m., Mr Gade had walked to the lighthouse and radioed to the coastguards at Hartland Point to let them know that all was well on the island.

Below, the current shop on Lundy moved into its present location in the top of the Linhay in the 1990s. Formerly it had been in several locations including in the Tavern as pictured above. (As previously noted, MS *Oldenburg*'s arrival in 1986 led to an increase in both day visitors and people staying on Lundy. The 1993 removal of the shop back to the Linhay eased pressure on the Island Tavern staff.)

West Side Landings

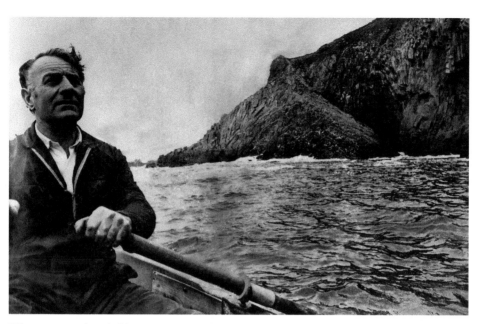

When an easterly gale blows it is impossible to land vessels on the east side of the island in the teeth of the elements. In former years vessels unloaded supplies and passengers in Jenny's Cove on the more sheltered west side. Passengers were ferried in a small boat to the foot of the Pyramid Rock as shown in the photograph above. They then negotiated the climb up the slope onto the grass above and then walked up the steep slope to the plateau above. The lower photograph shows staff dragging a mountain-rescue sledge laden with baggage up the slopes to the track above. West side landings are no longer done because of the risks involved.

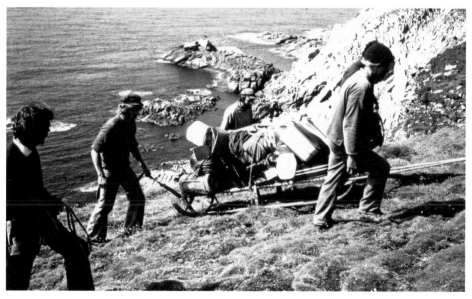

The Castle

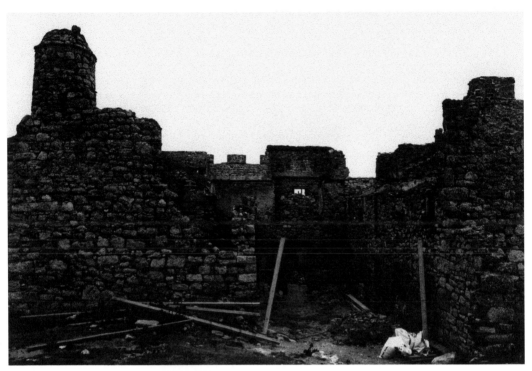

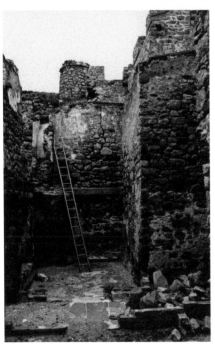

Facing North Devon, the castle commands a fine view of the east coast of Lundy, the landing bay and the Channel. Archaeological evidence suggests that the existing building and the surrounding site date from the Civil War. There is no evidence of a medieval construction. When Landmark took on the island in 1969 the castle was once again a ruin. The cottages had lost all but fragments of roof, and though the stairs were present, the timbers were rotten. In July 1975, Landmark appointed the stonemason Mike Haycraft to consolidate the external walls. At that time there were two proposals: the castle could either be repaired and left as a maintained ruin or it could be fully restored as hostel accommodation. It was decided that the castle should be rebuilt and the little cottages within be restored as accommodation for tourists.

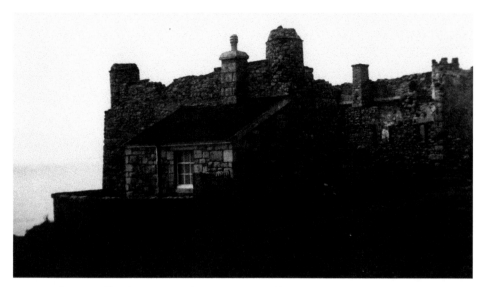

In 1894, the post office had a granite hut built against the north wall of the castle keep. This was to house the terminal of the new submarine telegraph cable from Croyde. The point of entry for the telegraph cable can be seen low down on the hut's west wall. The Cable Hut above had one room and a small lobby, and was enclosed by a retaining wall. In 1956, Albion Harman decided to extend the hut to make a larger holiday cottage. This was done very simply: by building up the retaining wall round the hut and then roofing it over, leaving the hut itself still standing inside. For the floor of the new main room, the slate bed of the billiard table from the Manor Farm Hotel was used. Below Steve Pratt, the Lundy ranger, is assisted by volunteers on a working party to consolidate the parade ground walls nearby.

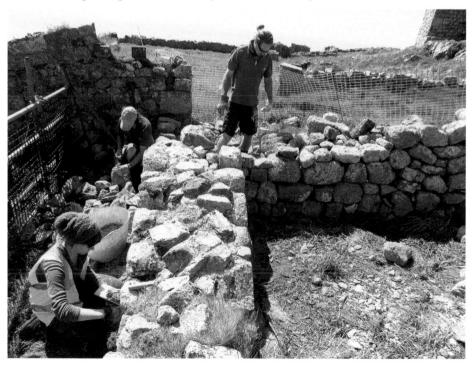

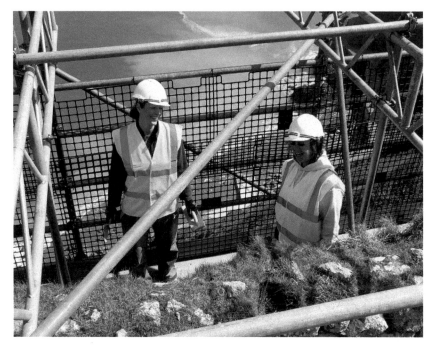

From 1983 to 1984 the Manpower Services Commission had a team on Lundy rebuilding the exterior bailey walls, perched high on the edge of the cliff above the beach road to the east of the castle. In May 2013 Landmark had concerns for the stability of the parade ground wall following noticeable erosion, caused mainly by rabbits. The task began of repairing and repointing the exterior bailey wall. With £35,000 of funding secured from the National Trust, elaborate scaffolding was erected over the wall, providing safe access (and marvellous views!) over the landing bay. The weather was kind and the job was completed in good time.

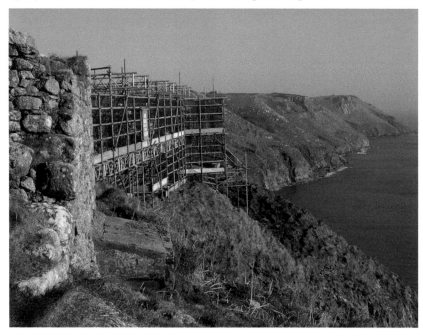

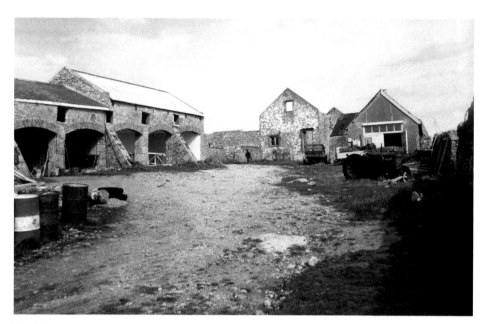

The Tavern gained more space in the 1950s when Albion Harman moved the shop into the Linhay, an open-fronted farm building facing onto the green, built in 1890 by a Mr Wright. The shop returned to the Tavern when the Campbell steamers called less frequently. Above the Linhay is the ruin of the Barns. Below, on the deck aboard the *Polar Bear*, is Revd Peyton-Jones chatting to Bob Bendall, the mate of the vessel. Revd Peyton-Jones was a founder of the Royal Marines Special Boat Service (SBS) before he became a clergyman. While vicar of the North Devon fishing village of Appledore, he wore his green Royal Marines beret, white cassock and sandals, cutting a striking figure.

Signal Cottages

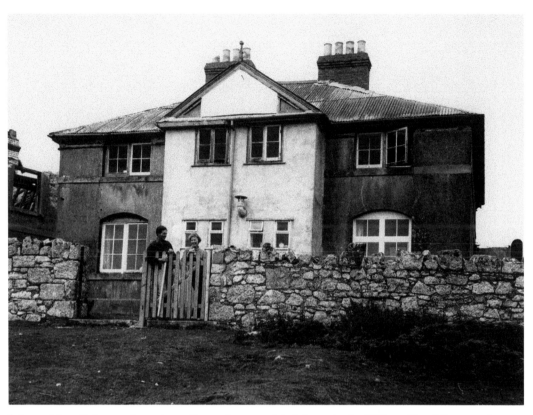

John and Joan Dyke are pictured standing at the gate of their home in the 1970s at Signal Cottages. It was from here that he worked as resident Lundy artist and editor of the *Illustrated Lundy News*. He also designed many of the postages stamps in the early years of the Landmark Trust on Lundy. It was decided to demolish Signal Cottages to make the nearby castle much more prominent on the skyline above the landing bay. The cottages also housed the island post office many years ago.

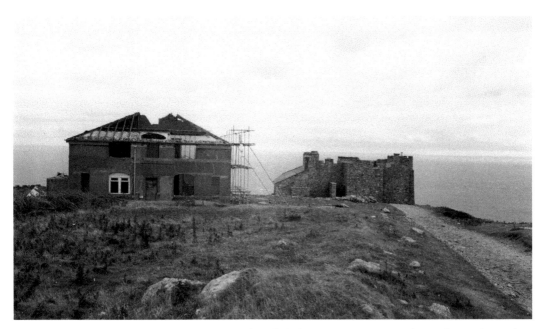

In the 1980s the Signal Cottages were demolished to give priority to the castle nearby and its prominence on the headland above the landing beach. In 1898, Frederick Allday became postmaster, when the post office was moved from the island store to Signal Cottages, where he worked as Lloyd's signalman. In 1909, when he retired from Lloyd's, he moved the sub-post office from the Signal Cottages to the Cable Hut and continued his postal rounds with his donkey Irwin until 1926. Thursday was the recognised mail day, weather permitting. The mail boat waited around two hours so it was possible for speedy correspondents to send back their replies. The left-hand cottage was rented out to holidaymakers.

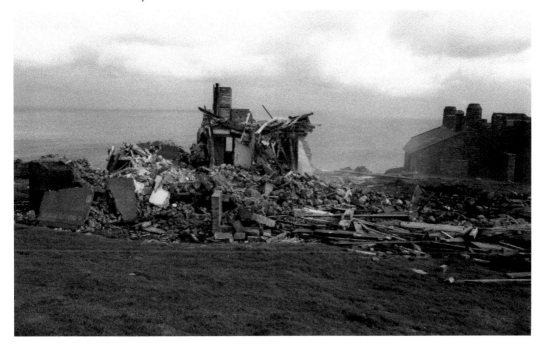

South Light

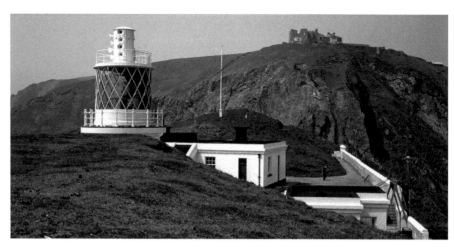

The South Light, pictured in the 1960s – you can see Signal Cottages behind the castle ruins still in need of restoration. The South Light was first illuminated in 1896 along with the North Light, having been built in 1897. It replaced an older tower on the highest point of the island, which had notable problems: a light that flashed too fast, a red sector light that appeared to merge with the main light and the risk of fog shrouding the light because of its height. The 'new' lighthouse forms a triangle between Itself, Hartland Point and Bull point, which help vessels traverse the water between the mainland and the island. The lights on Lundy were popular with lighthouse keepers as they qualified as rock stations. The keepers would earn more money for serving at these two lights, which were the only rock stations with a local pub to hand! The pub is, of course, still open today.

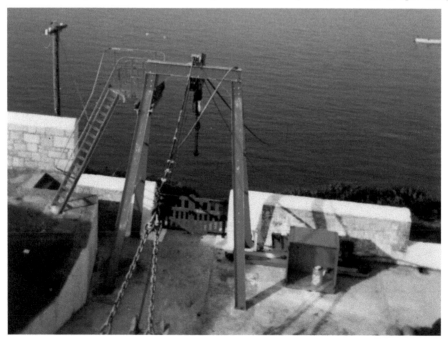

The Tavern

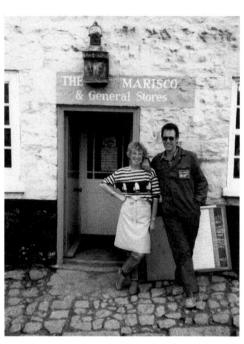

On the right are Reg and Jilly Lo-Vel. Jilly was the daughter of John and Joan Dyke of Signal Cottages, and Reg had come over for the reconstruction of the village in the early 1970s. He stayed with Landmark for many years. Below is a group in the Tavern from the 1970s with an array of life belts from various ship wrecks around the coast of the island as well as vessels who serviced Lundy through their lives.

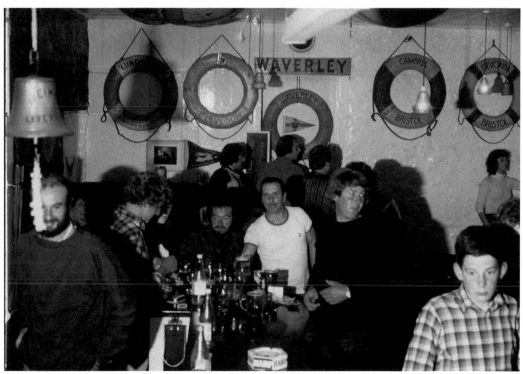

Above is Ernie Dowding, an enduring Lundy character, in one of his flamboyant shirts. He came over in the 1970s and frequently visited Lundy for decades thereafter doing plumbing work in properties. His ashes were laid to rest in a poignant service by friends on Beacon Hill in 2014. Below is the famous mural in the Tavern, painted by John Dyke, showing the landing bay. The mural is still there behind the bookshelf by the Wheelhouse room door. The Tavern is much changed now, but remains in the same location it has always occupied.

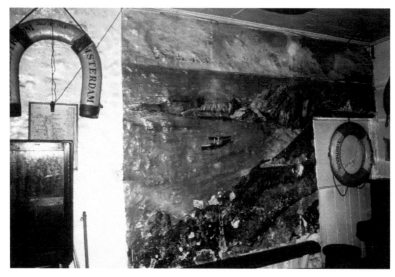

The Old Light

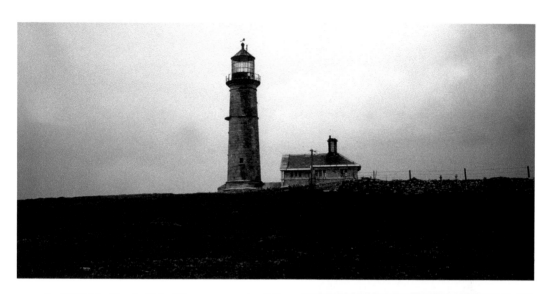

In 1947, Mr Martin Coles Harman gave the Old Light rent-free to the Lundy Field Society, which used it for many years as their headquarters, with a basic hostel in the care of a resident warden. Landmark carried out a major restoration programme at the Old Light when they took over the island. The first priority was to renew the tower's windows. These had disappeared, so allowing water ingress. In 1976, Mike Haycraft fitted new windows and, as there was no handrail, had to wear a safety harness attached to the wall. The two keepers' quarters had remained as a hostel since 1969, being gradually improved and modernised. In 1982–83, they were returned to the original arrangement of an upper and a lower flat.

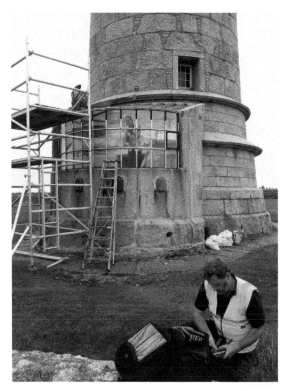

These 1970s works were carried out as part of a large programme undertaken over two years by the contractor Ernest Ireland Construction Ltd of Bath, when all outstanding major restoration works on the island were finished off in one go. During the spring of 2012 Landmark further restored the lantern room, thanks to a generous legacy from Mr Peter Williams. To tackle the intricate job, contractors who normally service lighthouses for Trinity House were engaged to complete the work. In 2015 the lower lantern room was also restored by National Trust heritage masons Charlie Smith and Rachel Thompson and other staff. Charlie and Rachel are prominent in many of the restoration projects on Lundy today.

Stoneycroft

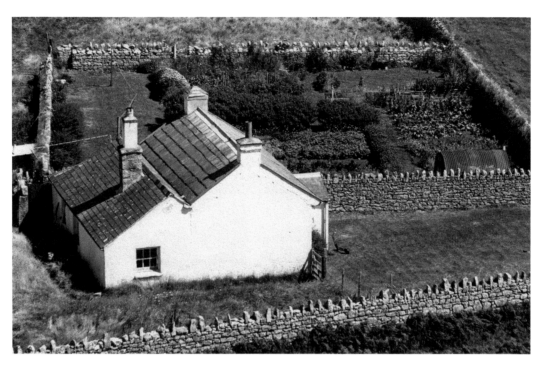

This single-storey cottage was built in 1821 for the use of the Trinity House agent and other visitors. With sudden changes of wind direction, or the rising of a gale, ships were unable to depart and there were occasions when visitors could be stranded for several days. In 1988 Landmark converted Stoneycroft into a holiday cottage for four people. The porch was removed and the sitting room and main bedroom exchanged places. Pictured above shows when it was a residence for staff living on the island. Below is Stoneycroft undergoing refurbishment in the 1970s.

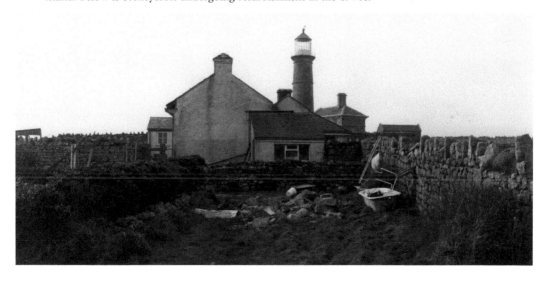

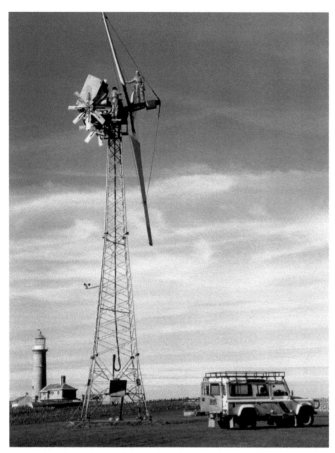

The image on the left shows the aero-generator, erected in 1982 to harness free energy from the Atlantic winds. It stood as a visible reminder that, on an island, energy efficiency must be a way of life. The aero-generator eventually succumbed to the Atlantic winds and, after blowing over several times, it was dismantled in 1996. There are now three modern generators in the village supplying all the electricity required. Below is a view of the Old Light in the distance from the south-west corner. As part of 50th anniversary celebrations of Landmark in 2015, Sir Antony Gormley installed sculptures at several Landmark sites across the UK. Lundy was chosen for one of these sculptures and it stood for a year overlooking that prominent location on the south-west corner of Lundy.

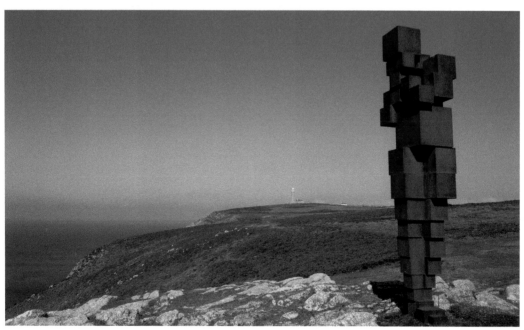

The Queen's 1977 Visit

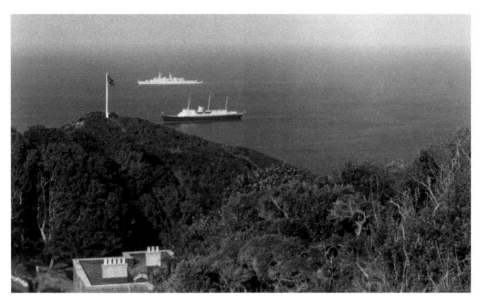

The Queen, the Duke of Edinburgh and princes Edward and Andrew enjoyed a day off on Sunday 7 August 1977 during their West County tour. With rare informality, they visited Lundy island and walked upon it for three hours in perfect weather. Only a handful of people knew of the imminent visit and their lips were tight until Saturday night when the island's thirty inhabitants plus seventy visitors were called to a meeting in the Church of St Helena, the only building large enough to contain them all. It was the first ever visit by a reigning monarch to the island, although the Queen Mother had landed there – also from the royal yacht, *Britannia* – in 1958. Above the royal yacht *Britannia* escorted by a naval warship in Lundy Roads beyond Milcombe House. Below is Mr John Smith escorting Her Majesty to the beach when the royal party departed.

Raffle tickets were issued to visitors on the island to determine who might have the opportunity to meet the Queen. A lucky school party from North Devon were visiting the island on the day and the children had a great surprise bonus for their day out. Above and below are views of the Queen and her party leaving Lundy. Thirty-two years later, in 2009, Prince Edward, as the Earl of Wessex, returned to Lundy with Sophie, the Countess of Wessex, on another visit.

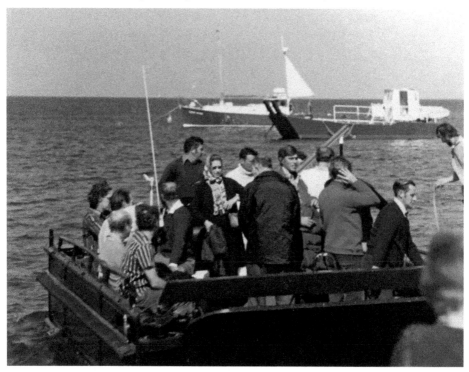

The Battery

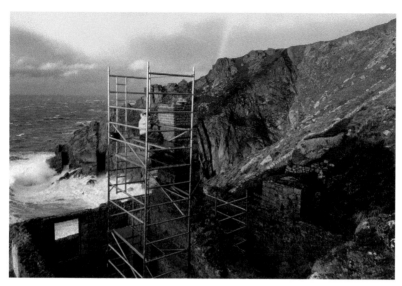

The Battery complex was built in 1863. During foggy weather the sound of the guns was intended to warn shipping of the close presence of the island. The Battery cottages were the living quarters for the Trinity House Battery keepers. The cottages were in a much eroded state and needed consolidation, which was completed by Charlie Smith and Rachel Thompson from the National Trust in 2018. Further down the cliff to the west is the Battery, and flanking this building are two 18-pound cannon. The guns are made of iron and bear the royal cypher 'GR', indicating that they belong to the reign of George III (1760–1801). These too have been restored to protect them against the elements and one has been repositioned into the Battery itself.

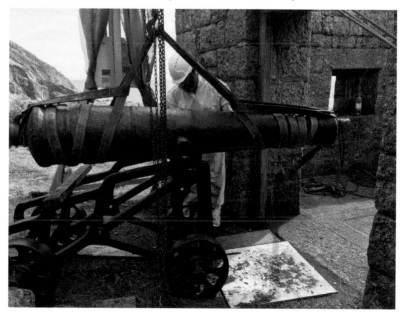

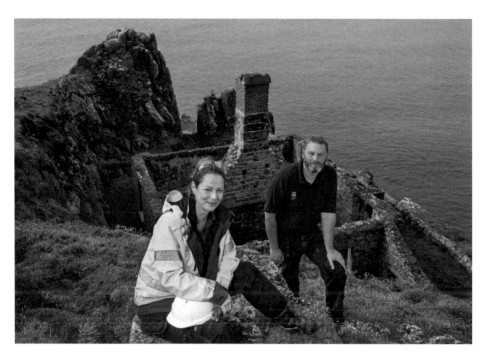

Above are Charlie Smith and Rachel Thompson, formerly from the National Trust, but since working on Lundy heritage projects and buildings they have formed their own company called Old Light Building Conservation. They now take their expertise for heritage restoration around the nation as well as on Lundy. Image courtesy and copyright to James O. Davies of Historic England. Below is an image of the North Light, constructed in 1896 showing the man-hauled tramway leading to the winch and cable building where goods were hauled up from the Trinity House supply vessel. The red radio beacon aerial on the left was inadvertently constructed on land not owned by Trinity House.

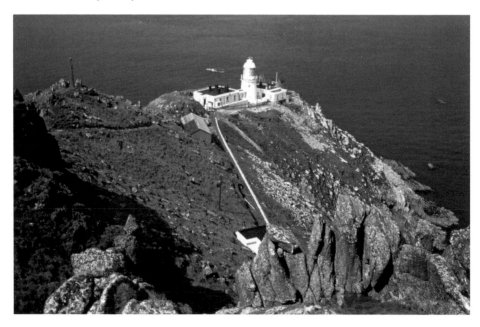

The North Light

Lundy North Lighthouse was first lit in 1897 – the light was produced from a 75-mm petroleum vapour burner until 1971 when electricity was installed. The station was automated in 1985 and modernised in 1991 when it was converted to solar power. These images were taken at the end of the tramway where the main winch cable building was situated. The current light is located atop of the old fog signal building and is not inside the lantern. This renders the whole lighthouse and its two connecting houses completely unused. Therefore plans and alterations are in hand to take over the building for accommodation; conversion work commenced in March 2019.

The Beach Road

In the mid-1990s another significant landslide occurred near the 1969 slippage site. This time it engulfed the remains of the Sea View Cottage building and covered the road on a day when MS *Oldenburg* was arriving with a full boatload. The swing shovel and manpower was quickly mobilised to clear the road just as the first visitors arrived for their day trip. It was clear that the beach road was in need of significant work to provide a long-term secure access onto the island.

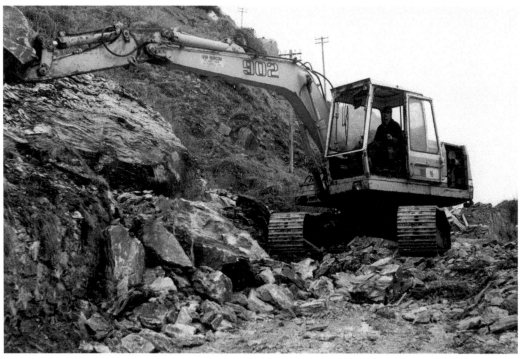

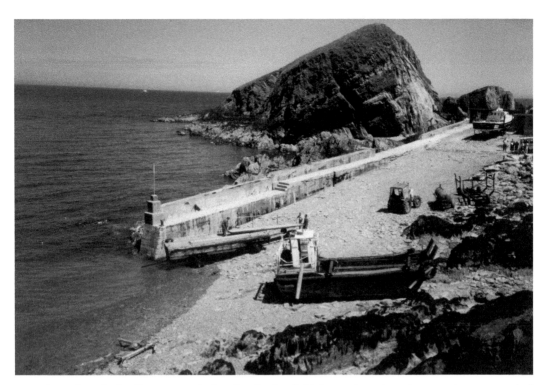

A road to the landing cove tucked under the South Light, at the point where previous owners had constructed the concrete harbour wall, was planned many years before the arrival of the new jetty in 1999. Above the Shearn craft is sheltered in the harbour, and the evidence of a tractor having driven there suggests this photograph was taken in the 1990s. Below a new JCB digger had been ferried out by the *Lundy Puffin* the work boat from Appledore Dockyard for delivery. It is being unloaded by the island swing shovel, which was being used to gradually carve out the new road past the South Light to the harbour.

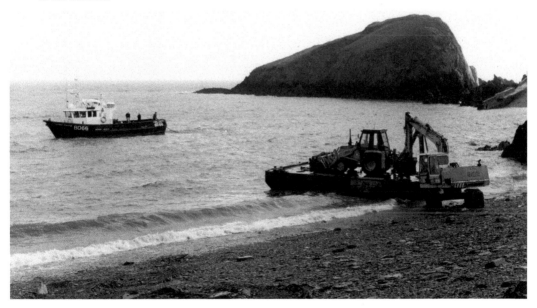

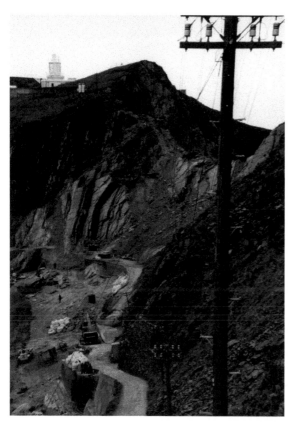

One of the most significant projects undertaken by Landmark was the construction of the road from the slipway landing along the edge of the cliffs past the Sentinel Rocks. Thousands of tons of rock were dug away, which took many months of work with the digger and swings shovel. This major programme of roadworks funded by grants had been accomplished in various stages along the face of the cliff below the South Light. This followed the collapse of a large part of the rock face due to the nature of the sedimentary rock in this location. The work required the input of consulting engineers who designed a retaining wall incorporating sprayed concrete reinforcing sheet mesh to support the road that runs like a shelf some 3 to 5 metres above the beach.

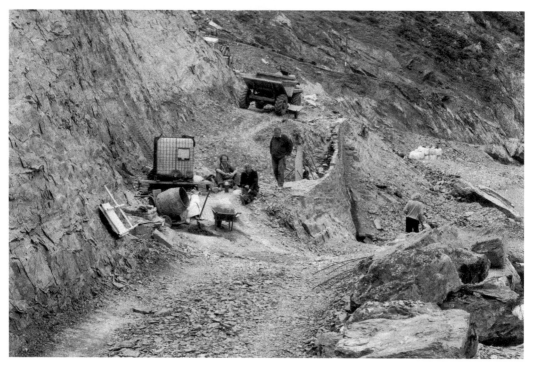

Ties of threaded steel rods (rock anchors) have been let into the cliff face running below the road surface with frequent anchor plates incorporated into the mesh reinforcement. In addition, lengths of heavy plastic gas pipe have been inserted into holes drilled in the running surface of the road to act as safety valves for air that becomes compressed by incoming waves and is forced through fissures in the rock face where it has not been reinforced with the sprayed concrete mesh. As this cliff face is now the only way to reach the jetty, twice-yearly inspections are carried out to ensure any requirement for maintenance is identified in good time. The road was completed in 1998 around to the landing harbour.

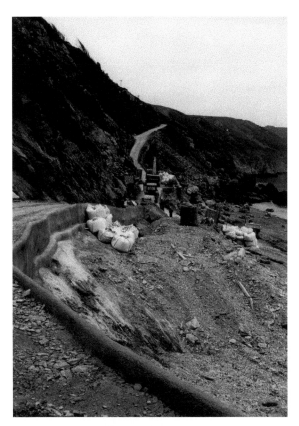

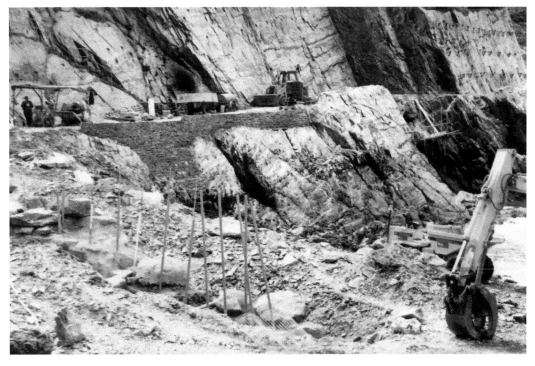

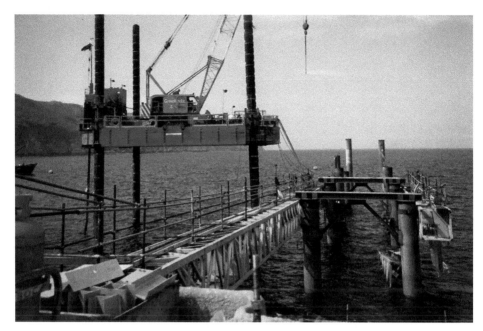

On boat days, when the Harman family were the owners of Lundy, most staff had to go down to the beach to help put out the landing stage and man the boats bringing visitors to the island. This was not efficient and needed changing. The solution to increasing efficiency lay in building a jetty. Building out from the existing slipway posed many problems and it was decided to site it as an extension from the existing concrete breakwater to shield the small landing beach next to Hell's Gate. After a major collapse of the cliff face, a new roadway was already being constructed around the base of the headland below the South Light leading to the Cove landing place, which itself badly needed a tractor access. In 1999 the jetty was completed and now only two islanders are required to receive the ropes and provide assistance for direct offloading by crane from supply vessels into trailers and vice versa.

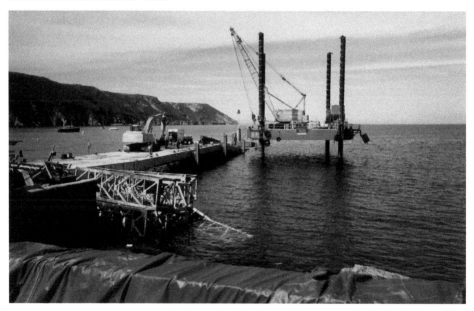

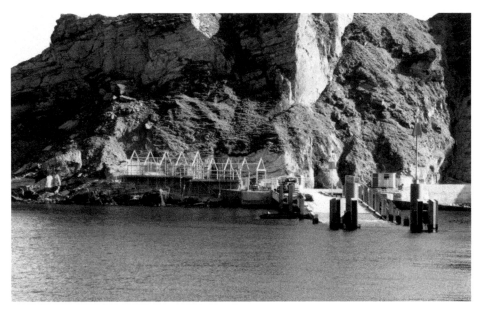

Various grant-making organisations were approached with the proposal to provide a more permanent beach building for the warden and the divers who visit annually. The existing buildings, no longer adequate, had been built close to the cliff face. It was clear that a further collapse of the cliff face was an imminent possibility, which would engulf the existing accommodation. Sufficient grants and other monies were obtained to construct a steel-framed timber-clad building akin to a whaling station. It comprises a combined boatshed and display area, with a ramp down to the Cove landing beach. There is equipment for charging air bottles, two changing rooms and a composting toilet for the use of the divers. The jetty building was completed in 2002.

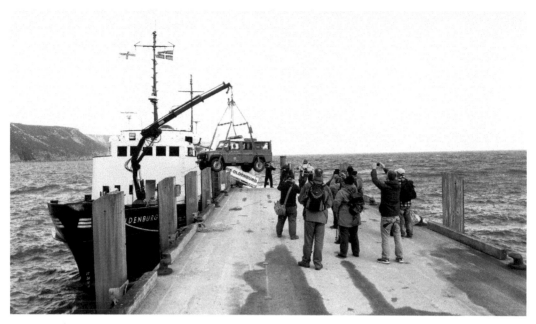

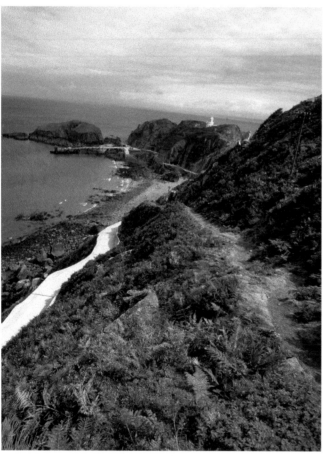

The jetty soon justified its existence and has become an integral part of island life. Now only two islanders are needed to receive the ropes and provide assistance for direct offloading by crane from supply vessels into trailers and vice versa. With jetty access, reliance on the Royal Marines at Instow to ship and unload heavy equipment has been almost eliminated. The island can deal with most heavy items without mainland help, for instance the delivery of the new fire engine above. The proportion of successfully achieved landings of passengers is now much higher. When there were easterly gales blowing or forecast in years gone by, all landings had to be diverted to the west side or even abandoned entirely.

The Church

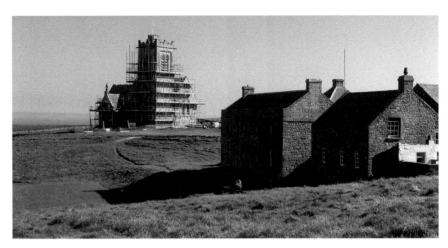

St Helen's Church is a building that is at the centre of the island community and has played an important part in the island's history as a place of worship for over 100 years. It was built by Revd Hudson Grosset Heaven in 1896 with a generous bequest in 1895 from Sarah Langworthy (née Heaven). The builders were Messrs Britton and Picket of Ilfracombe, who had their own boat, *Kate*, to bring materials from Ilfracombe. However, much of the stone came from the former principal keeper's lighthouse cottage near the Old Light and also from the quarry. It is a Grade II listed building and was designed by John Norton, who was associated with Augustus Pugin and Gothic Revival. Above the church is seen shrouded in scaffolding in 2018. Below shows the marriage of Grant and Shelley Sherman, who live and work on the island. Shelley is a churchwarden of St Helen's Church.

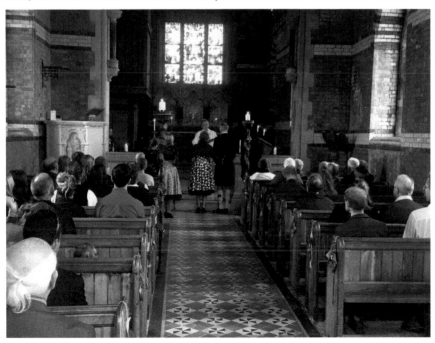

Left, pictured in the 1990s, are the eight bells that needed lowering from the precarious and unsafe bell tower. It had a peal of eight bells and in 2004 an additional two trebles, cast by John Taylor & Co. of Loughborough were added to complete the ring of ten bells. They are widely used by journeying ringers to the island, the church being regularly visited, and the bells rung by visiting 'towers' from all over the country. St Helen's is in fact one of the most rung towers in Devon. Below, an application for significant funding was successful with a large proportion deriving from the Heritage Lottery Fund with a grant of £999,600. That funding from the HLF for the St Helen's Centre appeal allowed for the repair and refurbishment of the church for present and future generations.

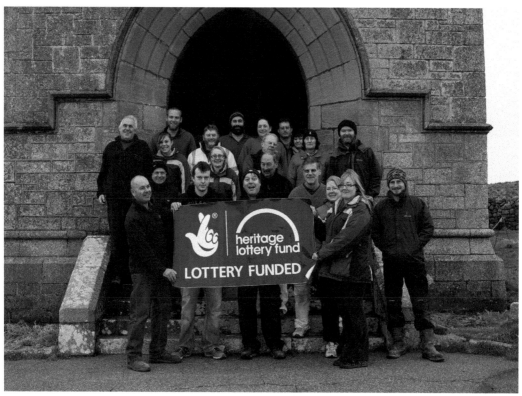

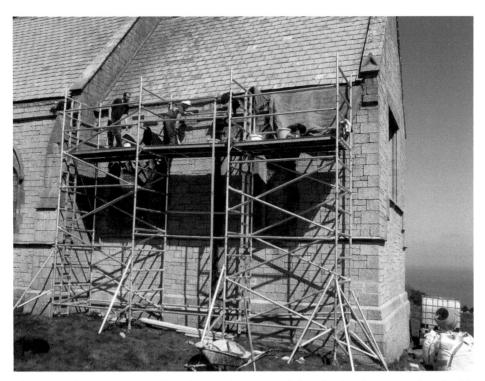

There is nothing between Lundy and North America and thus the church is exposed to the full force of the Atlantic Ocean. St Helen's was positioned out of the usual east–west orientation so that the south-west corner of the building cuts through the advancing storms. That, however, did not stop significant damage over the years. Parts of the roof had been renewed several times and recent storms had caused much more damage. A completely new roof renewal was necessary. Urgent works of repointing have now also been completed to prevent wind-driven rain entering the building through the granite walls. The high Gothic window was also damaged some years ago in a storm. It has now been completely restored, with a new upper section being inserted.

Specialist stonemasons were employed to repair the limestone windows and framework. The interior was completely cleared, as can be seen here. Woodworm-infested pews were removed and, where possible, cannibalised to make six good bench pews for the new church. The parquet flooring was completely restored. The south-east window above the altar received a newly designed stained glass and plain glass contemporary look. Much of the original nineteenth-century look has been retained, but very modern features include a new vestry with accommodation for visiting clergy or research students along with an exhibition display to the rear of the church.

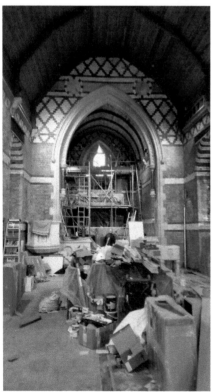

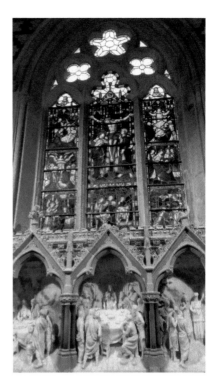

The Bishop of Exeter, the Right Revd Robert Atwell, led a ceremony at St Helen's Church on Lundy island on Saturday 30 June 2018 to mark the successful completion of the nine-year restoration project. As part of the restoration project, a new exhibition has been installed in the church and Siân Cann, Lundy's assistant warden, has been given the role as education officer. The building has even been used as emergency accommodation only a few months ago in April 2019 for weather-stranded visitors.

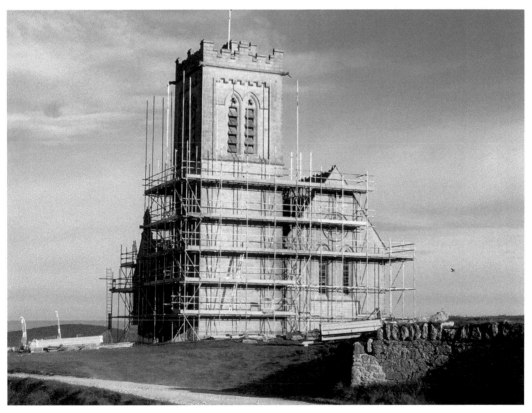

In an Emergency

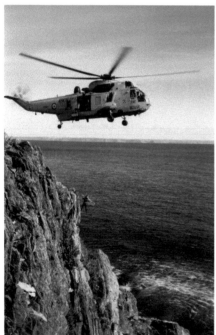

The emergency services do not take long to access Lundy. In former years a distress beacon had to be lit on top of the island to alert doctors, lifeboats and the coastguard, but now with modern technology an emergency helicopter can be on Lundy in no time. In these images from the 1990s a doctor climbing on the south end of the island in company with a group of other doctors accidentally fell. He self-diagnosed several fractures and the RAF Air Sea Rescue helicopter from Chivenor attended to airlift him to hospital. The coastguard now provide cover along with the Devon Air Ambulance charity so despite the removal of the RAF from Chivenor, emergency capabilities have been retained.

Brazen Ward

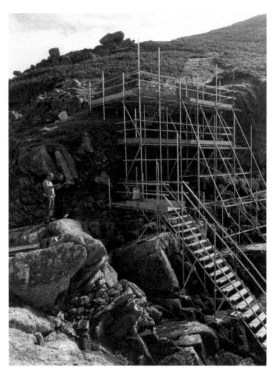

Brazen Ward is one of the best-preserved sites of an early gun battery on Lundy. It is certainly several hundred years old, but whether it goes back as far as the Tudor period or merely the Civil War is uncertain. When Her Majesty the Queen visited Lundy in 1977 the royal party landed here at Brazen Ward, having arrived in the royal yacht, *Britannia*. It is an exposed east-facing coast. Some erosion and damage had been sustained over the years so in the summer of 2017 a restoration project was undertaken. Many tons of scaffolding were erected and all equipment had to be brought to the site by boat – a precarious task even in good weather. Again, Charlie Smith and Rachel Thompson's restoration and stone-working skills came to the fore at this exposed location.

Vessels

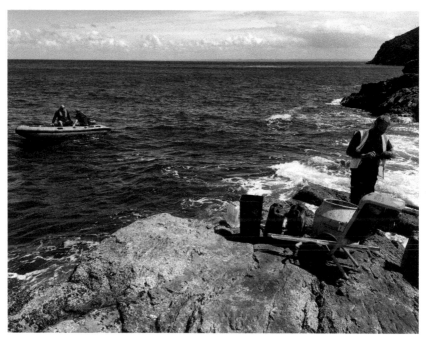

From small to large, seaborne vessels are the lifeline to Lundy. At Brazen Ward in 2017 everything was brought to the site by boat, including the concrete mixer on the ridged inflatable. Over the years the Royal Marines Amphibious Trials and Training Squadron at Instow have trained their crews on landing craft by providing much-needed support to the island. Below is a cattle lorry taking off stock during the 1996 drought when feed and water supplies were a challenge. Livestock was of necessity removed to Somerset for welfare purposes.

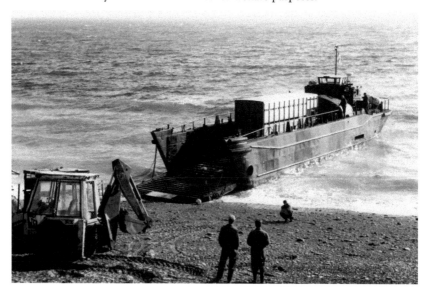

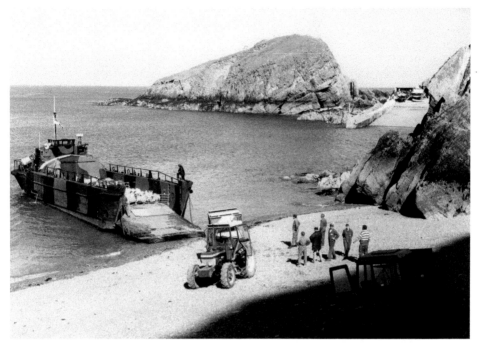

Above, ponies and sheep were driven down to the beach and loaded for transportation to the mainland – all in a day's work for a Lundy farmer and a useful training opportunity for the crew of the landing craft vessels. Below is an image taken in the 1960s prior to the various landslides that removed Sea View Cottage, the nearby shed and the beach road. It shows one of the P&A Campbell boats, *Devonia*, ferrying visitors to and from one of the paddle steamers. These little boats were left on Lundy for the season along with the Campbell's workforce who helped out on Lundy when there were no ships scheduled that day.

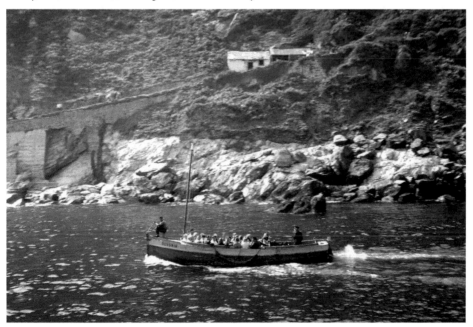

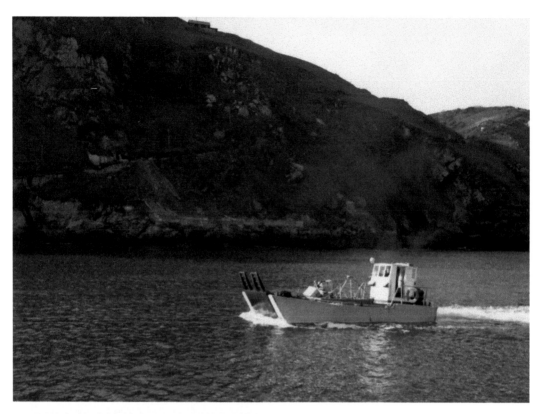

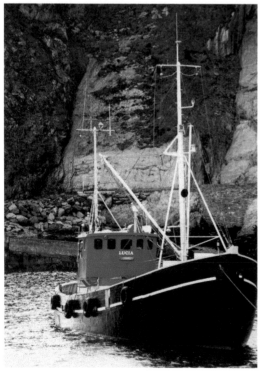

Above is the *Shearn*, which was built for the purposes of transporting stores and goods between the *Polar Bear* (and later MS *Oldenburg*) and the landing slipway. She was built by John Shearn and was sold some years ago when the jetty was built. She now works on the River Thames in London carrying stores and goods. On the left is the Trinity House supplies ship the *Lucia*, pictured below the cliffs near the South Lighthouse. Here was once a cable winch from the seabed up to the light to carry stores and equipment to the heights above.

The *Polar Bear* and the *Gannet*

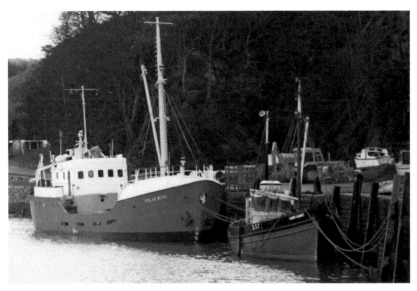

David Beer worked aboad the *Polar Bear* from 1976 to 1982 as one of the two engineers employed by the Lundy Company. He records that the vessel was built in 1960 for the Greenland Trade Department and sailed under the name of *Agdleq* prior to purchase by the Lundy Company in 1971. She made a fine picture forcing her way into a stiff westerly in the Bristol Channel, her gleaming post-office-red hull contrasting with her white superstructure. Sailings to the island were carried out twice a week in the winter and three times a week in the summer. She was licensed to carry twelve passengers and was sold in 1985, being replaced by the MS *Oldenburg*. She is pictured above next to the *Lundy Gannet* in Ilfracombe Harbour. They worked alongside one another for a few years. Below is *The Lundy Gannet* pictured in the landing bay while island staff are getting ready to unload cargo and passengers.

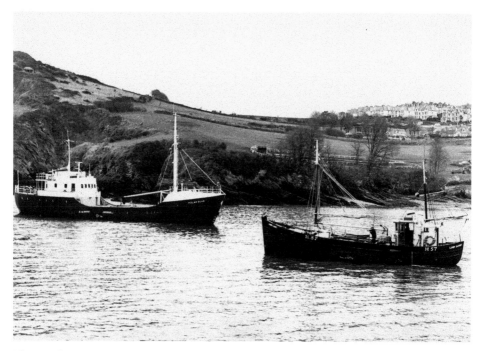

The *Lundy Gannet* passing the *Polar Bear* on her way out of service, leaving the *Polar Bear* in 1978 in sole charge of supplying Lundy. The *Gannet* was chartered and licensed to carry up to twelve passengers between Bideford and Lundy island in the 1960s to 1970s. She was built in Lossiemouth in 1949, originally named *H57 Pride of Bridlington*, where she was based until *c.* 1954 when she left for Bideford. She continued to serve Lundy until the late 1970s when she was sold and her place was taken by the *Polar Bear*. Below, on the deck of the *Gannet* are passengers on the way to Lundy in very basic conditions by comparison with modern journeys on board MS *Oldenburg*.

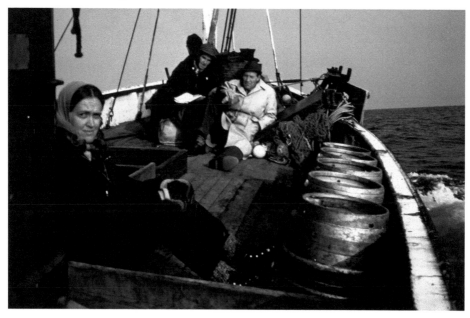

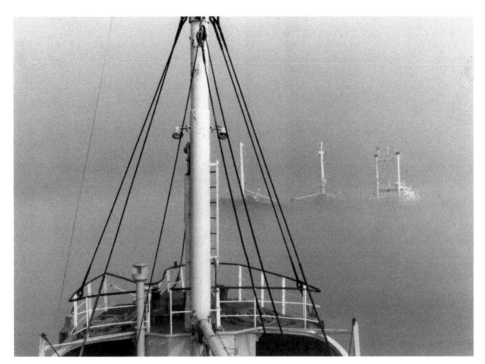

Above, a photograph taken by Mark Perrins from the bridge of the *Polar Bear* in thick sea mist in 1983 when a collision occurred with the 3,000-ton MV *Arosia*. The repairs to the *Polar Bear* were carried out at Dartmouth at the Philip & Son dry dock in October that year. Below shows the damaged *Polar Bear* laid up at Ilfracombe awaiting onward voyage to Dartmouth.

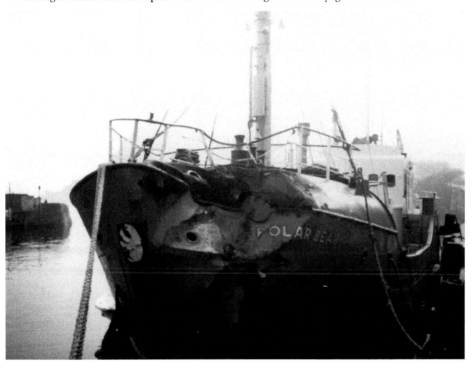

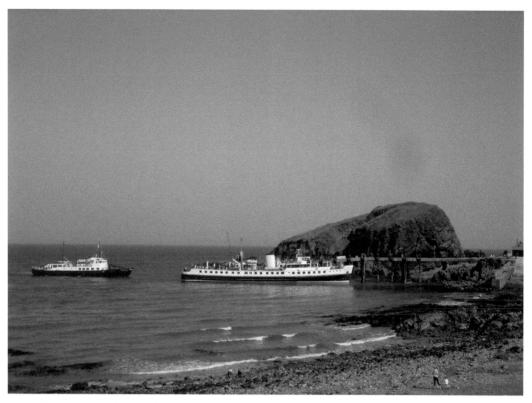

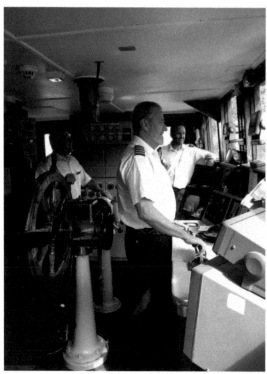

Above, the MS *Oldenburg* approaches the jetty behind the MV *Balmoral* on a sunny day when their sailings occasionally coincided. The MV *Balmoral* was built in 1949 for the Red Funnel Line service between Southampton and the Isle of Wight. In 1969, she relocated to the Bristol Channel as part of the P&A Campbell White Funnel fleet. She was acquired in 1984 by the Waverley Steam Navigation Company, joining the National Historic Ships Register in 2002. The MS *Oldenburg* replaced the *Polar Bear* and, while the latter was a reliable cargo ship, regulations limited it to carrying only twelve passengers. A suitable new vessel had to be found so John Puddy, the Lundy agent, and Barty Smith, one of the Lundy directors, went to Germany to view the MS *Oldenburg* at Wilhelmshaven. She was originally built for the German railway company as a ferry operating between the German mainland, the Friesian Islands and Heligoland. Below is Jerry Waller, former master with his mate Brian Slade. The current master, Jason Mugford, is in the background.

84

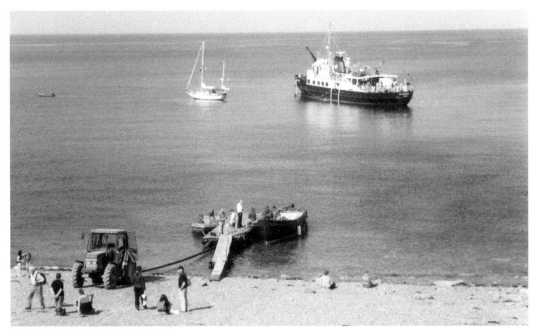

A view of MS *Oldenburg* in the days before the jetty, in her original livery with red funnel. The blue *Cobble* tender boat is in the foreground unloading passengers. When the MS *Oldenburg* had first been viewed in Germany she was running as a butter cruiser, exploiting a loophole in the law by selling duty-free butter out at sea. For this purpose her aft saloon had been gutted and converted into a supermarket; otherwise her condition was as originally fitted out. She dropped anchor for the first time off Lundy on 5 December 1985 after an eight-day journey from Germany, and made her first passenger trip on Saturday 10 May 1986. Below is the ship called the *Dawn Light*, which was in possession of the Lundy Company in 1988/89 and was bought for the construction of a harbour, but that plan was dropped and she was sold.

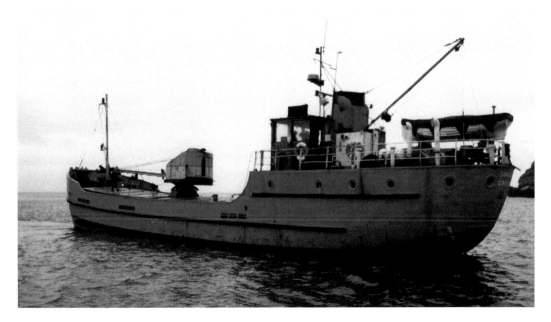

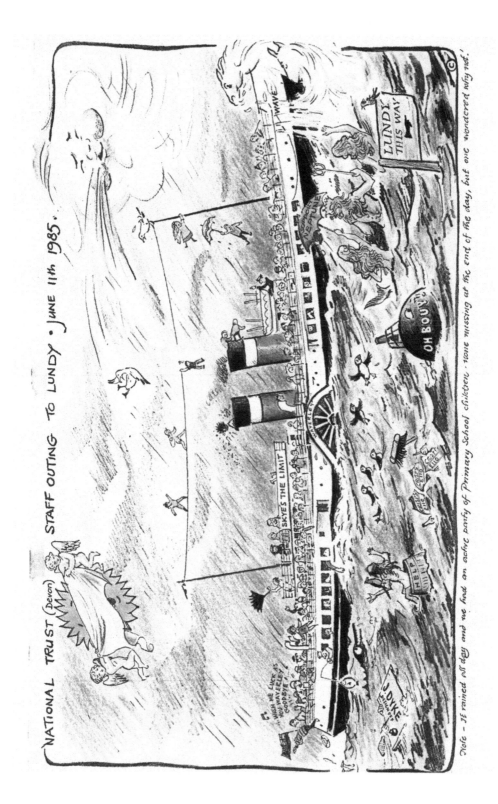

John Dyke, artist and editor of the *Illustrated Lundy News*, was famed for his cartoons and caricatures. Here we have an amusing image following a National Trust staff outing in 1985 on board the paddle steamer *Waverley*.

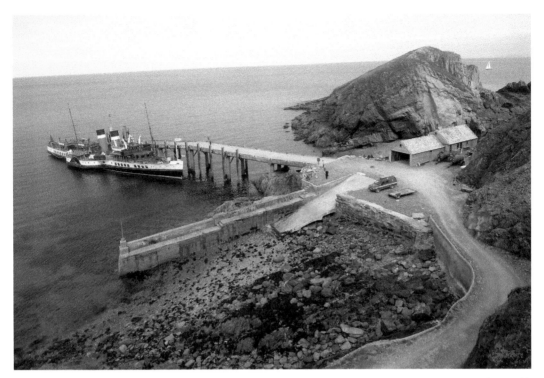

Above is the PS *Waverley* moored on the jetty and is the last seagoing paddle steamer in the world. Magnificently restored with towering funnels, timber decks, gleaming varnish and brass, she visits Lundy when on her tours of the Bristol Channel area. Bought by the Paddle Steamer Preservation Society, she has been restored to her 1947 appearance and now operates passenger excursions around the British coast. Since 2003 *Waverley* has been listed in the National Historic Fleet by National Historic Ships UK as 'a vessel of pre-eminent national importance'. Below is a close-up of MS *Oldenburg* in 2019 leaving Ilfracombe for Lundy.

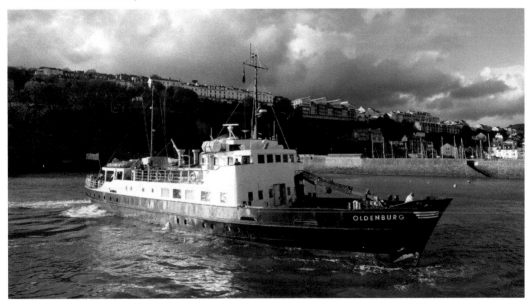

The Lundy Stamps

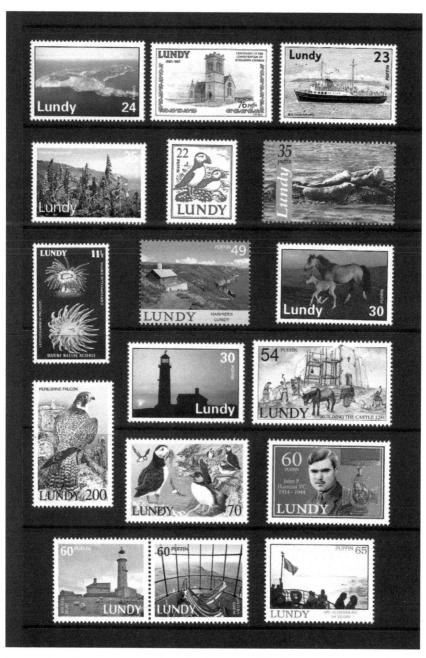

Lundy runs the oldest private postal service in the world still active today. The first stamps were issued as early as 1929. The Landmark Trust has continued the service and issued new stamps during its fifty years in charge of the island. In September 2019 there will be a new set highlighting Lundy's Golden Jubilee.

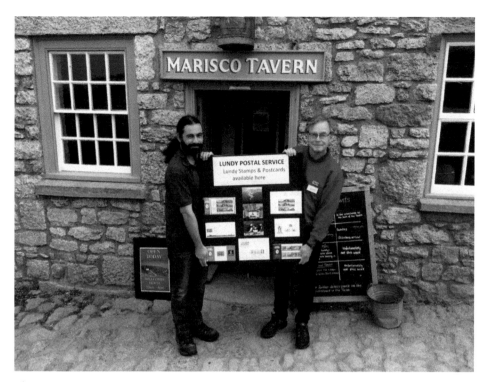

The stamps are an important part of the island's unique character, creating much attention and publicity for Lundy all over the world. The Lundy stamps are used on all mail dispatched from the island, not least the many thousands of postcards sent every year by visitors. They are also much sought after by many stamp collectors worldwide. Above Postmaster Ceri Stafford and Lars Liwendahl outside the Marisco Tavern announcing the Landmark Trust stamp issue in 2015. A temporary post office is usually opened in the Tavern on the day of issue of new stamps. Below is Lars with Derek Green, Lundy general manager at the launch of the Lundy Birds stamps issue. These stamps were painted by Sharon Read.

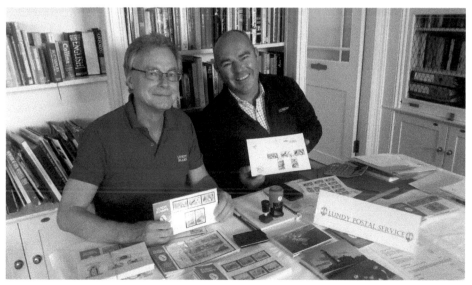

During the last fifty years, Lundy has had several different postmasters. Firstly, the legendary resident island agent Felix W. Gade. Other well-known personalities include Reg Tuffin and Ceri Stafford. Grant Sherman, left, is the current postmaster. Since 1989 the island has been assisted by Lars Liwendahl, a long-time Lundy friend and former employee in the designing of many stamp issues. Above on the Landing Beach in 1992 is John Dyke (far left) with his wife Joan and daughter Jill. To the right is Lars Liwendahl and his wife Karin. John was a very skilled artist and known for his many island drawings. Together with his wife, he edited the *Illustrated Lundy News* from 1970 to 1975, and he designed most Lundy stamps from 1951 until 2002.

Lundy 2019

Above: There are twenty-seven letterboxes to locate on Lundy, but they are all hidden. To find them a series of clues has to be followed. Each letterbox contains a rubber stamp that is unique to its box. The objective is to discover where all the boxes are located and collect the stamp imprint. Letterbox packs are available to purchase from the island shop and compasses available for hire should you not have one. Below: There is a fixed-wing airstrip on Lundy just north of the Old Light across Ackland's Moor and parked aircraft are always a feature of interest on guided walks.

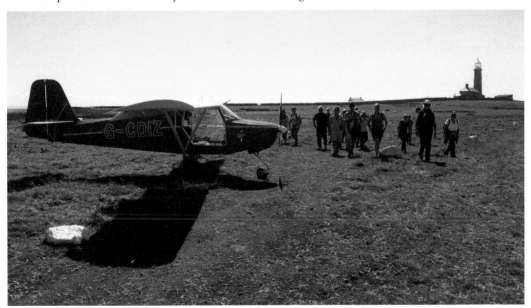

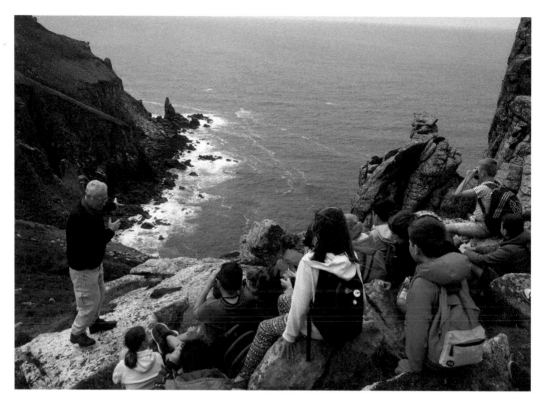

Above: Education and interpretation feature highly in the voluntary work of the Lundy Ambassadors who are guides and educators specialising in taking groups, including schoolchildren, around the island. Here they are watching the puffins in Jenny's Cove. Below: The regular trade stands at the county and local agricultural shows promote the island to a wider audience, again supported by the Lundy Ambassadors. Lundy is marketed far and wide across the West Country by staff and volunteers alike.

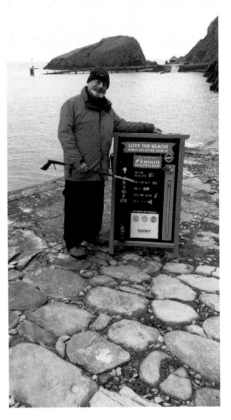

Lundy now embraces many designations for protecting its environment for the enjoyment of visitors and for the long-term sustainability of its wildlife above and below the waves. Visitors are encouraged to also embrace the many initiatives that can support the conservation of this unique landscape, the 2Minute Beach Clean being only one such initiative. Our visitors also now have the opportunity to use the Tramper mobility vehicles shown below to discover parts of Lundy that had always been difficult for those with mobility challenges to access. Lundy is now open and more available to so many more people than could ever have been envisaged fifty years ago in 1969.

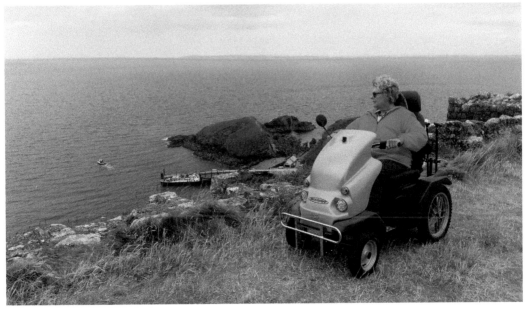

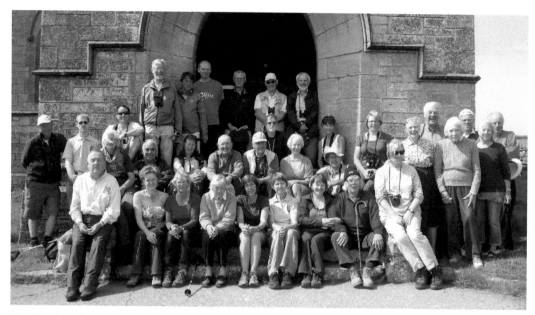

The Lundy Field Society (LFS) was founded in 1946 and for many years had its headquarters in the Old Light on the island. The LFS is now a charity that has as its aims the study of Lundy, in particular its history, natural history and archaeology, and the conservation of its wildlife and antiquities. Above are members of the LFS pictured on one of their Discover Lundy weeks on the island and below is a photograph of (on the left) the late Dr Myrtle Ternstrom BEM who was a long-standing member and significant author on Lundy. Myrtle is accompanied on the right by Diana Keast, the daughter of Martin Coles Harman. It was Diana and her sister Ruth along with their sister-in-law Kay Harman (the widow of Albion) whose very brave decision to sell Lundy set into motion the saving of this unique island for future generations.

Dean Woodfin Jones, the present warden on Lundy, came to the island in 2017. Being a self-confessed island lover, he quickly settled into his role and is supported by his assistant warden Siân Cann. They in turn are supported by rangers, volunteers, ambassadors and the whole of the team on Lundy in managing the conservation and well-being of the wildlife. In the half-century anniversary year more school groups than ever have been engaged in visits and activities both on the island and also back in the classroom. The new material developed for young people has been warmly welcomed and ensures that a new generation of Lundy-loving young people will carry on that great work for years to come.

The Lundy Staff 2019

Some of the staff and Landmark team on Lundy in 2019 with buildings restored since 1969 in the background.

Acknowledgements

Such a book would be impossible to write without the assistance of innumerable people on and off Lundy. Reg Lo-Vel, who arrived with Landmark in 1970 and eventually became agent for the island, has been generous in loaning his entire collection and in particular images by his late father-in-law John Dyke. Alan Rowland, chairman of the Lundy Field Society, has also been very helpful in the provision of images from his own collection and that of the Field Society. The stamp section must be attributed to Lars Liwendahl from Stockholm who co-ordinates the Lundy postal stamp productions. The late Roger Allen offered his knowledge and images freely, as did Roger Chapple and the late Dr John Watson and family, regular visitors to Lundy in the 1960s and 1970s and up to the present day. Sharon Read, artist, who produced recent images for stamps, has assisted greatly, as has her partner Tom Baker. Chris Price, the mainland agent for Lundy in the years following the arrival of Landmark, has afforded his long historical knowledge of the workings of the Island. Images have been loaned by James Davies, Alan Pearce, Mark Wolf, Martin Thorne, Mark Perrins and Philip Hunt. Others too many to mention are owed a great debt of gratitude in putting together this record. I would welcome any information in correcting any errors or omissions within this book, for which I accept complete responsibility.